VERMONT BEER

HISTORY OF A
BREWING REVOLUTION

KURT STAUDTER & ADAM KRAKOWSKI

AMERICAN PALATE

Published by American Palate
A Division of The History Press
Charleston, SC 29403
www.historypress.net

Front cover: Courtesy of Patrick Breen.

First published 2014

Manufactured in the United States

ISBN 978.1.62619.482.3

Library of Congress CIP data applied for.

For Patti and Noella

CONTENTS

PREFACE

He long considered the brewery in this town a nuisance; but it is now closed, and he did not believe anyone present would ever see another brewery running in Burlington.
—anonymous Burlington rum seller, May 11th, 1877.[1]

When the publisher proposed this book, we thought that it would be a simple task of pulling the material together and collecting it into one place. It turned out to be considerably more involved. While we divided up the work into two parts, before and after Prohibition, each of us found that the subject was like any number of the complex and nuanced beers that are being created today in Vermont. The more we dug into it the more we found that we wanted to write about, and each time something new was revealed, it would send us in another wonderful direction. At some point around the time the publisher set as our deadline, we had to call it quits and go with what we had. In our opinion, this is the most concise history of beer in the Green Mountain State from the time of the First Republic to the present, but there is no doubt that over time more interesting material will be revealed. Then there is the fact that the craft brewing scene in Vermont is in an incredible state of change. New breweries are popping up all the time, and we look forward to the contributions they will make to Vermont's beer culture.

We hope that you enjoy reading this as much as we enjoyed putting it together for you. Now grab yourself a glass of your favorite Vermont beer and settle in for quite the story.

ACKNOWLEDGEMENTS

KURT STAUDTER

First off, I'd like to thank my dad, George Staudter, for instilling in me my love of beer. It was part of his German heritage, and now, it's part of mine. I must say thank-you to my brothers—Tom, who is the real writer in the family, for his constant encouragement and Rob for always being there with a cold beer when I needed one the most. Sessions of beer drinking with my family are among my fondest memories and happiest times. Sherry; my kids, Courtney, Emily, Orion and Tyler; and grandkids Abel, Aiden and Brody; have all given me good reasons for a beer at one time or another.

I'd like to thank my friend Paul Kowalski, who, through his columns in the *Yankee Brew News*, taught me almost all I know about Vermont beer. One can't ask for a better wingman on a beer adventure.

Without access to the *Yankee Brew News* archive, this book would have been incomplete. Thanks to publishers Jamie Magee and Bill Metzger for allowing us that privilege.

Toby Garland was incredibly generous in trusting us with his Vermont beer memorabilia collection. From this access, the book has a number of wonderful images. Thanks, Toby.

Thanks to all the beer writers who cover New England and Vermont: Tom Ayres of the *Yankee Brew News*; writer Dan Kochakian, along with

publishers Tony Forder and Jack Babin, at *Ale Street News*; and the folks at *Beer Advocate*. They all do a great job of keeping us informed and entertained on all things beer.

Thanks to Corin Hirsch at Seven Days and Jim Welch at VTBeer.org for their constant support of Vermont brewers.

Finally, I'd like to thank all the brewers in Vermont for all the joy you've brought to my life. I hope this side project didn't distract me too much from my duties with the Vermont Brewers Association. It really has been a pleasure for Patti and me to be associated with such a wonderful community.

Which reminds me, let's not forget Patti, who has been my first line editor and is always up for that next beer adventure. Prost!

Adam Krakowski

First and foremost, I would like to thank Thomas Visser and Robert McCullough from the University of Vermont graduate program in historic preservation, which is where this project was born back in 2009. Traveling the back roads of Derby, Vermont, documenting historic barns, I never could have dreamed where this has gone. I also must thank Dr. Heather Darby at the University of Vermont Extension School for her support in my historic endeavors.

I would like to thank everyone at the Vermont Historical Society for their support and for awarding me their Weston Cate Research Fellowship in 2010 that allowed me to forge ahead in documenting Vermont's history of hops farming and brewing. I owe the brewers of Vermont my sincere gratitude for embracing my research and being always willing to hear any interesting finds. A thank-you goes to writer Dan Kochakian for helping with my pursuits in beer history

This project would not have been possible without my wife, Noella, who is my keystone. Her unquestioning support of my historic pursuits and writing no matter where they have taken me, has been a gift. I owe a debt of gratitude to Majka, Ma, Mel, Lou, Nejla, Ed and Elli, who all pushed me forward in life. Lastly, I would like to thank my father for instilling in me a passion for history, a respect for knowledge and daring me to always be better.

PART I
BREWING AFTER THE REVOLUTION

BANTER

"How to Court Irresistibly; or, The Loves of Mr. Wiggins and Mrs. Wedille"

Oh, sweet Mrs. Vaddle, don't frown such a drown,
You'll ne'er get a lover more truer,
Should you search through the country, or look through the town,
Than me, Billy Viggins, the brewer.
Than the stout that I now drink to you, my dear ma'am
'Pon my honour, my love it is stouter;
You have knowd me sometimes, and you knows wat I am,
But you can't say you knows me a spouter.
Then pray, Mrs. Vaddle, be sweet as is malt,
Not bitter as best Kentish hops is,
If any rival you wed, you'll be greatly in fault,
For you don't know wat animals fops is.
But if you will have me, then, O dear, how I'll strut,
Mine's a flame that will never expire—
My rival may prove, should you wed him,
all but,
But, depend on it, I am entire
His looks were like amber, his cheeks were not pale,
His eyes, O they sparkled like cyder;
He swore that his love was as strong as his ale,
And it was not his wish to deride her.
Though his speeches were frothy, his motives were clear,
By the brisk way he fixed to court her,
For, say he, my dear angel, although I [unreadable] beer
You'll remember I deals too in porter.
Mrs. Waddle, she found to deny was in vain,
He declared he'd adored, since he knew her,
And as she, pleasant creature; could never give pain,
Why—she wedded young Wiggins the brewer.[2]

1
1789–1839

GROWING PAINS

Vermont's history with beer and brewing from 1789 to the emergence of the first modern breweries was tumultuous at best. At every step—from the republic to statehood to federal Prohibition—Vermont has always had to combat circumstance. Unlike many other regions of the United States, Vermont never established a brewing tradition. Given the current state of Vermont's brewing revolution and reputation, an assumption can be made that there was a long and decorated history of brewing tradition to pull from. Simply put, before Greg Noonan's Vermont Pub & Brewery and Catamount Brewing Company, there was no legal brewery in Vermont for over a century. Between a state-induced prohibition that started in 1853 up to federal repeal of the national Prohibition in 1933, Vermont's sociopolitical climate suffocated any and every attempt of brewing. While some breweries in the state attempted to carry on their trade, shipping the beer mainly out of the state, their attempts to continue onwards proved to be futile. With the last brewing operation within the state of Vermont closing in the 1880s, a century-long vacuum in brewing occurred. Unlike New York City, Philadelphia and Boston, which all had long traditions of breweries and noted brewers stretching hundreds of years, Vermont struggled to establish a stable brewing industry. During a four-decade period in the nineteenth century, Vermont established itself as one of the largest producers of hops in the country and the largest in New England. Yet while Vermont had the agricultural capabilities of producing beer from the farm fields, there were less than a dozen breweries in total until 1989.

Vermont has always been a place that is unique regardless of the topic. The creation of the state of Vermont did not happen with the American Revolution. Vermont was the subject of land claims, stemming from the language in each state's grant from England, from both New York and New Hampshire. In 1764, King George III granted the territory to New York. New York's claim on Vermont was short-lived. On July 8, 1777, at Elijah West's Tavern in the town of Windsor, the constitution of Vermont was drafted and effectively made Vermont its own sovereign territory. The historian Peter Onuf referred to the complex and unique situation that Vermont endured to create its own independent territory as "the only true American republic, for it alone had truly created itself."[3] Vermont did not join the United States of America as the fourteenth state until 1791. It was during its time as a republic that Vermont's documented beer history started.

The opening chapter of beer and brewing in Vermont is not the opening of a brewery but of a lottery. In eighteenth-century Vermont, the legislature granted permits to hold a lottery as a form of sanctioned fundraising for civil projects. These lottery permits granted the applicant a set amount of money that could be earned through the actual drawing. Lotteries in this manner were an important aspect to establishing many important public works, such a libraries, colleges and prisons. John Hubbard of Weathersfield was granted a permit on October 26, 1789, to raise £150 for the purpose of erecting a brewery and malt house in Weathersfield. Although John Hubbard was granted the right to hold a lottery, the managers of either the lottery or brewery (it is unclear which) were Samuel Cobb, Lemuel Hubbard and Samuel Steel, all of Weathersfield. The notice appeared as:

> *The Managers of Weathersfield-Brewery Lottery hereby notify the public, and the adventurers in particular, that the drawing of said lottery will commence on Wednesday the 6ᵗʰ day of October next, at the house of Joseph Hubbard, Esq. in said Weathersfield. Those persons that have received tickets for sale are desired to return the obligations and the tickets if any remain on hand, before the drawing of said lottery; A few tickets remain in the hands of the subscribers, and at the Printing office in Windsor, for sale.*
> *—Samuel Cobb, Lem. Hubbard, Samuel Steel, Managers*
> *Weathersfield August 23, 1790*[4]

An advertisement in the February 24, 1790 issue of *Spooner's Vermont Journal* stated that the "lottery is to erect a Malthouse and Brewery, for the

purpose of manufacturing Strong Beer, a liquor more healthy and cheaper than the imported spirits and distilled liquors." The advertisement went on to state that the brewery would bring great benefits to the community.[5] It is important to point out that in nearby Windsor, Vermont, on December 28, 1788, a fire destroyed a malt house owned by Eldad Hubbard, leaving the region without any noted malting facility.[6] Malt houses were important agricultural components to communities and an event such as the fire in Windsor would have created a void in the area. John Hubbard must have run into difficulties in erecting the brewery because there are records of a second sanctioned lottery on November 3, 1791, to erect the brewery for £200, this time with a partner, A. Downer.[7] Only months later, another lottery was announced at the end of December 1791 "for the encouragement of Manufacturing STRONG BEER &c. which promises great benefit to the Publick and individuals" and also noted that while the winners would receive money, there would be "a BOTTLE of BEER to the Unfortunate" from the managers Cobb and Steel.[8] The bottle of beer offering was a curious addition; all the lotteries before and after the December advertisement stated only that it was for the erecting of the malt house and brewery or just the brewery. It is unknown what the source of the bottles of beer offered by Cobb and Steel was.

A fourth and final lottery for $200 was granted on October 30, 1794, to finish the construction of the brewery in Weathersfield. This lottery was different than the three previous since the General Assembly of Vermont granted an "act to an act" (altering the original format of the previous lottery), appointing Daniel Babcock, Dan Clark and Amorose Cushman additional managers of the brewery lottery and on the same level as the previous managers. Due to unknown circumstances, Hubbard was never able to complete his brewery after spending five years attempting to get it operational. Due to the last lottery's lack of mentioning the malt house and only pressing for the brewing of strong beer, it is likely that the malt house was completed.

An announcement in the May 24, 1796 issue of *Spooner's Vermont Journal* announced yet another lottery to help launch the brewery, but no mention of John Hubbard is made, and the managers of the "Weathersfield Brewery Lottery" are Nathaniel Stoughton, Thomas Prentis and Amorose Cushman, with Cushman being the only carry over from the previous lottery. The drawing of the lottery itself was to be held that September at the home of Elias Liman in Weathersfield. A month before the drawing, an unlucky fellow took an advertisement in the paper that read:

I the subscriber,
Having purchased a Ticket in Weathersfield Brewery Lottery, of the
Number herein mentioned, viz. 1733, and it being mixed in with other
refuse papers, by misfortune, have lost it by fire.
Seth Norton
Strafford, April 9, 1796[9]

After this announcement, no announcement of the lottery or any further information on the Weathersfield Brewery is made in public record. Other records from the period suggest that a malt house was operational in Weathersfield belonging to a Hubbard, but no records of any brewery are found that could be Hubbard's dream of a brewery.

While the lotteries were occurring in Weathersfield, a March 30, 1791 advertisement in *Spooner's Vermont Journal* introduced readers to John Dumphy, a "master of three branches of business, malting, brewing of strong beer, worth from three shillings to six pounds per barrel, and distilling any kind of grain."[10] Dumphy's advertisement refers any person who would like information on him or to hire him for the purpose of distilling, brewing or malting to contact William Crague in Weathersfield. After one month of advertisements, no further mention of Dumphy is made in the area. With the lottery having been unsuccessful to establish the brewery and malt house and taking into account Dumphy's advertisement, the possibility existed that Dumphy was to be the brewer for Hubbard's malting house and brewery but was now looking for work due to the shortcomings of the plan.

Hubbard was not the only one to use a lottery to try to raise the capital to launch a brewing operation. In October 1792, Gamaliel Painter (a prominent Middlebury citizen and judge), Samuel Miller and Timothy Olcott announced in the *Vermont Gazette* that they were holding a lottery sanctioned by the General Assembly. They thanked the General Assembly for allowing the lottery "from their patriotic desire to encourage the beneficial manufacture of brandies, strong beer, &c., in this state."[11] What is uncertain is for what purpose the $1,600 that was raised for the trio would exactly go to. Unlike Hubbard, who stated his intentions of opening a malting and brewing operation, no clear declaration of intent was made on the advertisement. The outcome of the lottery is also unknown, and no further lottery was conducted by the trio in Rutland.

The first documented functional brewery in Vermont was in Middlebury dating between 1791 and 1792. The brewery was the creation of Jabez Rogers Jr., set up in conjunction with a distillery. Rogers obtained the land to build his brewery through his uncle Benjamin Gorton (of Hudson, New York), who purchased it from Honorable Gamaliel Painter in Middlebury in 1789.[12] While the exact date of the original launch of the brewery is unknown, an article in the June 12, 1792 issue of *Spooner's Vermont Journal* detailed how a supposed chimney fire ignited the brewery and distillery venture and burned the structure to the ground. The writer does give some tantalizing clues into Rogers's operation. The building "was 150 feet in length and completely finished" and "equal in value and convenience to any in America." The fire caused the operation to lose large quantities of brandy, gin and porter. While no one was hurt in the fire, the damage was estimated to be around $3,000, a truly large sum of money for the time. The importance of the brewery was shown by the residents' of Middlebury and surrounding towns donations of sums of money to rebuild the operation. Rogers, like John Hubbard, was granted a lottery to raise an astounding $1,200 to finish rebuilding and relaunching the operation. The new brewery and distillery were short-lived, as a second fire struck between the fall of 1793 and the winter of 1793–94. There was no record of a second lottery for Rogers to rebuild the operations once more, but an act of congress was passed to assist Rogers. On March 20, 1794, an act of congress entitled "An Act for the Remission of the Duties on certain Distilled Spirits Destroyed by Fire" specifically citing Jabez Rogers and the second fire that destroyed his newly rebuilt facility. The act enabled a distiller who has a total loss of inventory due to fire to not owe federal duties on the spirits produced.[13] A record in 1795 stated that there was a large porter brewery in Middlebury of a high quality. A later record that pointed out Rodgers's operation also went on to say that "cider and beer are also made [in Vermont], but these wholesome beverages are not in general use."[14] The brewery disappears from the records by 1797. While records exist citing the brewery's existence past 1793, no further record of Rogers rebuilding the brewery a third time are known, although records show Rogers in other pursuits.

Just fifteen miles away from Middlebury, in Vergennes, Jordan Post started a new venture very similar to Rogers roughly a year after the demise of the Middlebury operation. Post advertised in the November 7, 1793 issue of *Spooner's Vermont Journal* that he had "erected a house for the purpose of a Distillery, Malting, and Brewing, in the city of Vergennes—where everything

in their line may be had at the shortest notice, for Cash, Wheat, or Grain of any kind."[15] The advertisement also went on to state that cash would be paid for juniper berries and good quality hops. Not much else is known about the venture, as it disappears from the historical record after the series of advertisements in the winter of 1793–94. Post reemerged in March 1797 in Vergennes, carrying on a clock- and watch-making business in that town.[16] A similar situation occurred in Rutland with the David Tuttle Tavern "on the west side of S. Main St. on Gouger's Hill" that was stated to also be a brewery in 1799.[17] Only a fleeting reference is made to the brewery by John C. Wriston Jr. in his remarkable book on tracing the history of Vermont inns and taverns.

Account books from taverns in Vermont from 1795 to 1825 give detailed descriptions of the beverages served at the different establishments. Beverages such as slings (traditionally equal parts gin and water with sugar added), flips (beer based) and toddies (a sling but with rum), as well as glassfuls of rum (wrum or rhum), gin or brandy were traditionally served in taverns. Mugs of bitters were commonplace. Flips were especially common and popular. Timothy Hinman of Derby, Vermont, who operated a dry goods store and tavern listed serving flips among the other beverages. Cyrus Knapp who operated a tavern in Dover from 1818 to the 1830s also noted in his record books serving many flips.[18]

A flip is a "kind of liquor is made by putting a spoonful of brown sugar into about five or six jills of malt beer, which is then warmed by putting a hot iron into it, called a logger-head; afterwards, half a pint of rum or brandy is added, and the mixture well stirred with a spoon. Then a little nutmeg is grated on the top, which makes the flip for use."[19] Since the basic ingredient of this common beverage was ale, taverns already had the main component on hand and could easily accommodate the requests for the beverage. Interestingly, while Hinman and Knapp kept exceedingly detailed accounts on the daily expenses and sales of beverages, meals and lodging, no note is made on the acquisition of their spirits, ales or ciders. Their records include the name of whomever they purchased veal, beef, mutton or pork from and the cost of the meat. Flour and corn acquisitions were also recorded. It is hard to say the reasoning for omitting the acquisition of beer, but one hypothesis could be that such beverages were produced on site or within the town. Recipes were commonly printed in the newspapers throughout the state. One such example appeared in the *Federal Galaxy* published in Brattleboro:

Directions For Making Ale and Strong Beer (Brattleborough, 1797)
Procure a tub sufficiently large to hold the malt when it is mashed, and over
the tap fasten a little wooden box full of holes to keep the malt from running
out with the wort. Put two or three pails full of water nearly boiling hot
into the tub first, then as much malt as you can stir well together. Thus keep
putting in water and malt and mixing them well together to the consistency
of a thin pudding, till the whole is mashed [as] *you intend to brew. It*
should be kept covered down from two to three hours, when it may be let run
upon the hops, with a small stream at first. When you have drawn off what
wort there is in the mashing tub, put more water boiling hot upon the malt,
stirring it well together, after which it may stand one hour or till it is fine.
This may be done a third time or till you have your quantity of strong beer;
for small beer more boiling water ([or] *cold will do) must be put upon the*
malt, but the mash need not be stirred. Boil your wort with the hops very
fast one hour, taking care to stir it round, that it may not boil over, which
it will be very apt to do at first. When boiled sufficiently strain it from the
hops and get some of it cool as soon as you can. The yeast should be put to
a small quantity of beer at first, in cool weather, about the warmth of milk
from the cow; if the weather is warm, the beer must be something cooler.
When that begins to ferment, which it will do in two or three hours, more
beer may be put to it, and this continue to do at intervals, till nearly all the
strong beer is in a state of fermentation. It may stand in the working tub
from twenty four to forty eight hours, when it will be put into the barrel. As
the yeast works out, the barrel should be filled up for two or three days. It
may then be corked up, leaving the air hole open. In a week or nine days, the
beer should all be drawn out of the barrel, and the emptyings or grounds
taken out. It should then be put into the barrel again, and in a few days
corked up very close till fit for use. The quantity of malt may be from two
bushels to four to the barrel, the quantity of hops from six to ten ounces to
a bushel of malt. The stronger the beer the larger the quantity of hops, and
the longer it will be before it is fit for use. All the vessels used in the brewing
must be perfectly clean, and nothing used about it that is wet with anything
else. The yeast or emptyings used in fermenting the beer must be very fresh.
W.W. Brattleborough, Nov. 4, 1797.[20]

In the Northeast Kingdom town of Peacham, Ashbel Martin established
a malting operation around 1798.[21] For nearly three years, Martin ran an
advertisement in the *Green Mountain Patriot* that he had hired an "approved"
workman who was a maltster from Europe and they were "taking in grain

to malt [illegible] barley, wheat, rye, and oats; for which in exchange, malt of the best quality."[22] Martin also stated "any gentleman desirous of having a few barrels of Strong Beer brewed, may have it made good." With a gin distillery owned by William Moore and William Buckminster in production in the town around the same time as Martin's malting operation, Martin most likely produced strong beer only rather having a combination malting, brewing and distilling facility more commonly found around Vermont at the turn of the nineteenth century. By 1806, Martin's malting operation was no longer advertised in the *Green Mountain Patriot*, but "William Moore seems to have deserted gin in favor of beer, for in 1806 he advertised that he kept a constant supply of good malt at his malting works."[23]

Daniel Staniford established the earliest brewery in Vermont's largest city, Burlington, in 1800. The joint brewery and distillery was located near the northeast corner of Pearl Street and present-day Winooski Avenue.[24] The brewery produced "beer, ale, and porter, and manufactured other fluids which even the phlegmatic votary of lager cannot claim as non-intoxicating."[25] Staniford took out an advertisement in the *Vermont Centinel* on March 14, 1803, promoting his gin and also informing the public that, due to scarcity of barley that season, he would not be producing his strong beer that spring, but he intended to brew beer, ale and porter as soon as the grain was available. The advertisement also listed a classified for a young boy around fifteen years of age to come on as an apprentice as well as a "loyal" journeyman to assist in the venture.

By 1805, Staniford's brewery expanded. He now had a brewer, Philip Castle, who was offering up both strong and table beer alongside Staniford's gin and other distillates. Before coming to Burlington, Castle had brewed in Dublin, Ireland, for two years and in London, England, as an apprentice.[26] While Staniford previously brewed a strong beer at his brewery, the addition of a table beer was new. Taking the liquid of the second running from a stronger beer's leftover mash and using it as the base for the lower-alcohol beer made a table or small beer. Small beer was a way of not only utilizing as much of the grains sugars as possible but also creating a weaker beer that could be consumed throughout the day with far fewer effects than the high-alcohol strong beer that was also prevalent.

Breweries around the turn of the eighteenth century were often built in conjunction with distilleries, such as Rogers's and Staniford's operations. This was most likely due to having a malting floor to convert the raw grains into fermentable ones. Since both operations use the same core processes and ingredients, it is not difficult to see why early brewers in Vermont were

producers of both ales and spirits. Daniel Staniford's brewery and distillery, as well as his property, were announced for sale on March 24, 1831,[27] after about thirty years of operation. Considering the total amount of property and businesses included in the listing, Staniford must have been very successful in his endeavors as a brewer and distiller.

Shortly after Staniford started his brewery and distillery in Burlington, a similar operation by Loomis and Bradley emerged farther down at the head of Pearl Street. It is unknown how long the Loomis and Bradley business lasted since the earliest state census record, from 1830, no longer listed the brewery or distillery. The last advertisement placed by Loomis and Bradley inquiring on rye grain for sale was on September 7, 1827, in the *Burlington Free Press*. The ad stated that Loomis and Bradley, who also operated a dry goods store in Burlington, would be willing to pay cash or half goods for the procurement of rye grains delivered to the distillery. It is important to note that further advertisements were present in the papers through 1827 and 1828 requesting corn, barley, rye and sugar, but they make no mention of the distillery, instead requesting delivery to the store. The brewery is believed to have been part of the distillery.

To give an idea of how rampant spirituous liquors were in Vermont just after the turn of the nineteenth century, it is estimated that there were 125 to 200 active distilleries in 1810 within the state.[28] Distilleries in Waterbury, Burlington and Hartford, among many others, were producing gin. Distilleries in East Montpelier, Putney, Fair Haven, Townsend and Middlebury were producing whiskey from potatoes and grains. Applejack, or apple brandy, also made appearances in tavern books from that time period in Vermont. At the same time Vermont was saturated with distilleries, Connecticut's top exports were gin and hard cider, showing how financially viable and important alcohol production was. That is not to say that such copious amounts of alcohol being produced did not cause their own set of issues and problems.

Breweries in Vermont from 1789 to 1825 were usually part of a different businesses. To this point, there had been no stand-alone brewing facility, omitting malt houses. Rogers and Staniford had their distilleries aside from their breweries, and Billy Todd of Poultney was no different. An advertisement in the *Rutland Herald* on February 28, 1816, gave notice to the readers that Todd's brewery was in production near his wool factory in downtown Poultney and was fully functional. He advertised that he was producing both strong beer and porter "warranted to be as good as is made in Albany, and at the same prices."[29] Todd's advertisement is rather

unique in that he added footnote specifically aimed at farmers in the area. It states that Todd "recommends" to farmers that they specifically grow two-row barley instead of the "other" types of seed available because he would contract to purchase upward of six thousand bushels for his brewery at one dollar per bushel. He continued that he had a malting business as well as the brewery. There is, however, no statement on requesting the purchase of hops. This lends belief that hops production within the region was large enough to sustain Todd's brewing facility without any need for requesting a supplier.

Another example of such operations as Todd's is from John Thomas, an immigrant from England with thirty years of experience as a maltster who had the support of the town of Brattleboro to start his malting and, soon after, a brewery. Within his notice published in the *Federal Galaxy*, Thomas notes that he would finish his malt house by the fall of 1803 and would be brewing ale soon after malting was complete. Thomas also noted that he had received considerable support from local farmers and that he was experienced with both English and American malting methods. It is unknown if his malting and brewing operations were ever completed.[30]

While little is known of Todd's operation in Poultney in 1816, an article in the *Rutland Herald* in 1818 gives a rather macabre account of a Poultney brewer. On Monday, June 9, 1818, Bryan Ransom of Poultney was transporting barrels of beer from his brewery in Poultney to West Rutland that evening when disaster struck. It was thought that under the weight of the load he was transporting, the wagon on which he was riding fell apart. He was dragged half a mile farther down the road, entangled in the reins of his two horses that were pulling the wagon. The horses were found the next morning near a shed at the tavern of Mr. Gates, and after further inspection, Ransom's mangled body was discovered. Ransom was thirty-seven years old at the time of his death.[31] His death must have had an impact to the region since "on 18 June 1885, when the cemetery wall was under construction, workmen unearthed a blue marble stone erected in 1818 to the memory of Bryan Ransom of Poultney who was thrown from his wagon and killed at this site."[32] No other records of breweries in Poultney were found after Ransom's death.

Back in the Upper Valley region, Joel Marsh operated a brewery "near the new bridge over White River" in Hartford, Vermont. In a March 26, 1821 advertisement in *Spooner's Vermont Journal*, Marsh noted that he produced strong beer and porter at his brewery and had it constantly on hand. Marsh also advertised that he would want around three thousand bushels of barley

by the next fall, indicating that he had a brewery of moderate size.[33] It is unknown how long the brewery was functional. Other towns in the Upper Valley have local histories that lay claim to breweries, but such period documentation of them have passed to lore.

Another owner of a dry goods store who started a brewing operation in Burlington was Samuel Hickok, on the west side of Champlain Street.[34] Hickok placed an ad on March 7, 1828, in the *Burlington Free Press* expressing his intention to open a brewery and wishing to purchase six thousand bushels of barley, which is equivalent to around 270,000 pounds, along with 200 to 300 pounds of seed barley. By October of the same year, an announcement in the *Burlington Free Press* announced that the Burlington Brewery had fresh ale for sale. The same month, an ad appeared in the October 10, 1828 *Northern Sentinel*, that announced that the brewery would pay 62.5 cents per bushel (48 pounds) of barley if it is delivered that month to the brewery. A month later, an advertisement with the title of "Burlington Ale" noted that the beverage was for sale at the brewery and kept in constant supply. Based on the advertisements and newspapers, Hickok's Burlington Brewery only produced "Burlington Ale" since there is no mention of any other type of beer being produced at the time. While advertisements were present for a need of barley or other grains, it seemed there was never an issue with procuring enough hops for the brewery, as no requests or mentioning of hops were present in these advertisements in and around Burlington. The brewery's advertisements for having ale on hand appeared from late September through the early spring each year with no advertisements for the brewery running in papers during the late spring and summer months, suggesting the brewery was seasonally dependant on weather conditions and supplies of barley. Every time an advertisement ran for the purchase of barley, the advertisements stated that deliveries ran through the fall and winter. Every year, the design of Hickok's "Burlington Ale" advertisement changed.

A curious aspect of the advertisements placed in the different papers is that they have two different names associated with them. While the announcement of the brewery's launch and most advertisements thereafter carry either Samuel or S. Hickok, some advertisements carry the name E. Hickok. While the *E* never appears as a full name in the advertisements, it is very possible that either Samuel's second wife, Elizabeth, or even his daughter, Eliza, was an integral part of running the brewery.

Hickok cornered the Burlington market on ale for the first few years the brewery was open. While "Burlington Ale" was prominently advertised,

no other dry goods store in the city made any mention of ale for sale. Hickok's brewery is visible at the end of Champlain Street on Ammi B. Young's 1830 map.[35] The first advertisement of imported ale into Burlington is from a January 1832 advertisement in the *Burlington Free Press*. The advertisement announces the opening of a wet and dry goods store by Jonathan Allen on the corner of Church and College Streets and lists all the available products for sale. On the extensive list are barrels of "Ale & Philadelphia Porter."[36] This advertisement for "Philadelphia Porter" shows that importation of beer from a far distance was possible, leading to the possibility that ales from Boston, Albany or Portsmouth were in the Vermont marketplace at that time.

Hickok sold the brewery in October 1832 along with his dry goods store. An advertisement placed on October 12, 1832, in the *Burlington Free Press* stated that the stock of the brewery as well as the brewery itself had been purchased by H.W. Catlin & Co. It is also important to note that the last lines of the advertisement state that cash would be paid for any quantity of good quality of barley and twelve or thirteen hundredweight of well-pressed hops. This is the earliest known advertisement for hops in Vermont. The request for 1,200 to 1,300 pounds of hops in the *Burlington Free Press* suggests that such large amounts of hops were available in the Chittenden County region. Under the new ownership, the brewery was still producing "Burlington Ale." A noticeable change, though, was that the Burlington Brewery no longer had its own individual advertisement for its wares; it was reduced to a mere line: "Burlington Ale is now operational, orders for ale will be promptly attended to."[37] Catlin & Co. was dissolved on September 12, 1834, and became Hickok & Catelin, with H.P. Hickok listed as a partner. The brewery was still listed as the Burlington Brewery. One important change was the listing of not only barrels but also half barrels for sale.[38] This was possibly due to Catelin & Co.'s placing an advertisement for a journeyman cooper and a ten thousand white oak staves of barrel quality the year before.[39] At some point in late 1835 or early 1836, Hickok & Catelin sold the Burlington Brewery to R.N. Flack. H.W. Catlin's success can be seen in an 1853 map of the city of Burlington, on which there is a drawing of his large residence.[40]

Robert N. Flack was a Lake Champlain captain and Irish immigrant before becoming a brewer.[41] Flack retained the name of the Burlington Brewery but no longer produced Burlington Ale. By the fall of 1836, Flack had begun producing "Flack's No. 1," which was lauded in a *Burlington Free Press* article and was in high demand.[42] The brewery continued to advertise for the sale of ale and the purchase of barley, but little more is known of the

operation other than one advertisement placed in 1837. The advertisement from R.N. Flack was for the return of his strayed eight-year-old red and white-spotted cow to the Burlington Brewery with the promise that the finder would be "handsomely rewarded."[43] Flack operated the brewery until July 6, 1839, when a fire of unknown origin decimated the building.

2
1839-1879

DAMNATION OF ALE

The Burlington Brewery returned to operation under the ownership of George Peterson on September 11, 1840, who constructed a new building at the same location.[44] During the first year of operation, Peterson was advertising that he would have ale on hand into the summer. The brewery was producing around 1,500 barrels of ale a year.[45] By the 1850 Vermont agricultural census, Peterson's brewery consisted of only two men producing only 500 barrels of ale at a value of $3,000, translating to $6 for a barrel of Burlington Brewery beer. To produce the 500 barrels of ale, Peterson used 2,500 bushels of barley (120,000 pounds) along with 2,000 pounds of hops. The Burlington Brewery continued production past the onset of state prohibition but had a less public image, removing advertisements from the newspapers. The following decade of the 1850s was quiet for the brewery. Accounts of Peterson's production range from 500 to 1,500 barrels a year. Due to the growing temperance storm that was brewing throughout the state, especially in the eastern counties of Vermont, Peterson was probably trying to not attract any further attention to his business. Not much is known about the Burlington Brewery's production levels once prohibition was in place. It was not till the 1860s, after fifteen years in operation, that the Burlington Brewery came back into the newspapers.

Since the onset of state prohibition in 1852, the Burlington Brewery had remained out of the news except for legal issues. A January 11, 1867 article recorded that $47 dollars was stolen from the brewery. The next time the brewery made the news was more significant. On Monday, June 21,

1867, the terminal blow to end brewing in Vermont for a century started. That afternoon in Burlington, Sheriff Munson and Chief of Police Drew, accompanied by officers, executed search warrants for illegal liquor around the city. One of their search and seizures in Burlington was at Peterson's brewery, where the officers seized one hogshead, four barrels, one half barrel and four quarter barrels of ale, as well as a barrel's worth of bottled ale. The seizure of ale and subsequent arrest of Benjamin Peterson, the owner and brewer of the Burlington Brewery, marks the first time under a state or federal prohibition law that a legal and established brewer of beer was arrested for the nature of his work. Peterson's case was heard before the Chittenden County court on August 2, 1867, and continued through the Vermont legal system, culminating with his case heard before the January 1869 term of the Supreme Court of Vermont.

The details of the case before the Vermont Supreme Court are an important insight into both Peterson's operation and the cultural mindset of Vermont at the time. The key witness to the case of the prosecution was William Davis, a teamster who was employed by Peterson to carry away the beer. During the course of his testimony, Davis divulged that most of Peterson's beer "goes across the lake [Champlain]." Given that Peterson was accused of producing "Strong Beer," classified in Vermont then as beer exceeding 3.2 percent alcohol by weight (the current standard measurement of nondistilled alcohol is by volume), it is no surprise that the beer was shipped out of state. At the time of Peterson's brewery, a major distribution hub of goods was Plattsburgh, New York. While Burlington Ale, the flagship beer of the brewery, was the primary product, it is possible that Peterson used the second running of the malt to produce small beer that fell underneath the threshold of alcohol to sell locally.

The second witness used by the prosecution was Luman A. Drew, a curious character in the case. Drew testified that strong beer was intoxicating, though he provided no credentials to support his authority, and further stated that strong beer was produced at Peterson's brewery although he admitted that he had never personally witnessed the strong beer being produced. Under cross-examination, the witness admitted that his testimony was only hearsay.

The next witness was Thomas Rhodes. During the course of his testimony and at the assurance of the judge that his testimony would not be considered self-incriminating, Rhodes admitted that, roughly nine months prior, he had purchased a half-barrel of strong beer from Peterson that was delivered to the Rutland & Burlington Rail Depot.

The final witness called on in the case by the prosecution was Edgar Burritt. Burritt was a druggist based in Burlington and, while on the witness stand, was shown a bottle of beer from Peterson's brewery and asked what the liquid was. Burritt informed the court that it was a sour hop beer, either strong beer or small beer, and he did not know anything else about the liquid. His testimony concluded the prosecution's case.

Peterson was ultimately found guilty of the original charge and subsequently fined. A few years later, on July 24, 1872, Benjamin Peterson sold the brewery to John W. Carpenter. At the time of the sale, it was noted that the brewery was "in the business of bottling cider, soda, and mineral waters."[46] Due to issues within the sale, a court case ensued. One of the enticing details from the case was that ale, lager and porter were found on hand. By the time of the sale, the beer had been "soured" and was unfit for consuming unless it were blended. What is important was that Peterson had ale, presumably his "Burlington Ale," but also had on hand porter and lager. Although no porter or lager had been listed in the seizure at his brewery, it is possible that he started producing or had been producing these in addition to the Burlington Ale.

The Burlington Brewery returned when Ammi F. Stone and his son William took over. They carried on the brewery for nearly a decade, brewing around three thousand barrels (100,000 gallons) until 1882 or 1883. Although the brewery started brewing and bottling lager in 1871, it moved to Albany, New York, "on account [of] the stringency of [the] prohibition law" some time in 1882 or 1883.[47] In the spring of 1874, W. L. Stone's brewery was raided by the lawman Drew, who was at this time a sheriff. Authorities seized around forty casks of beer in the raid. After the casks were analyzed by Professor Collier and deemed "non-intoxicating," the beer was returned.[48] There was another record in the August 2, 1882 issue of the *Argus and Patriot* that noted that fifteen bottles of beer were seized at the brewery and were forfeited. Stone was found guilty and fined for the infraction. What is interesting about this specific seizure is that the bottles contained beer but had no notation of whether the contents of the bottles were ale, strong beer, lager or porter, which was the case with all the previous seizures recorded. Stone abandoned the brewing aspect of his operation shortly after his last infraction. William Stone turned the brewery into a successful bottling company of mineral and soda water that carried on into the twentieth century in Burlington. Ammi Stone passed away in 1886.

THE 1852 LIQUOR LAW

*Written by Joshua S. O'Hara, Esq., Appellate Public Defender,
Vermont Office of the Defender General*

[Liquor] *is a public enemy that, when discovered, the law smites.*[49]
Vermont's prohibitory law—Act No. 24 of 1852, or simply "the liquor
law"—gave rise to a number of interesting cases eventually decided in the
Vermont Supreme Court, many more than can be discussed here. One
decision, Robinson Powers's case, gives the modern reader a window into
nineteenth-century Vermont criminal and constitutional law, as well as an
insight into how Vermont courts at the time believed the U.S. Constitution
applied to cases in Vermont.

Robinson Powers of Woodstock likely had the distinction of being one
of the first people jailed under the liquor law, but not in a way you would
expect. In the late afternoon of March 8, 1853, the day the liquor law went
into effect, Windsor sheriff Lorenzo Richmond took Powers into custody for
breaching the domestic tranquility of Woodstock.[50] Powers lived in the same
house as his father, a man of "very advanced age."[51] The younger Powers
was overheard from outside the house "using very abusive and boisterous
language towards his father."[52]

Powers was charged with no crime. Instead, the sheriff jailed him under
a section of the liquor law that authorized a sheriff to hold someone who
drunkenly disturbed the peace in a "common jail" until "capable of testifying
properly in a court of justice."[53] Once the offender was sober enough to
testify, the law commanded that person to give a sworn statement about
when, where, how and from whom he or she had acquired the liquor he
or she had drunk.[54] If the person wouldn't give up his or her supplier, the
person would sit in jail until either giving up the supplier or until the county
justice discharged him or her.[55]

Powers chose not to tell who gave him the liquor, and he challenged his
detention on a writ of habeas corpus to the Vermont Supreme Court.[56]
Powers argued his detention violated Article 10, which protects against
compelled self-incrimination and guarantees the right to a jury trial,[57] and
Article 11, which protects against warrantless arrests,[58] of the Vermont
Constitution, as well as the Fourth, Fifth and Sixth Amendments to the
U.S. Constitution, which embrace the same subjects.[59] Essentially, Powers
argued that he'd been arrested without a warrant, jailed without a trial and

forced to give testimony against himself, all in violation of the Vermont and U.S. Constitutions.

Unfortunately for Powers, Chief Justice Issac Redfield didn't buy his arguments. He dismissed Powers's contention that he'd been unconstitutionally arrested without a warrant, noting that the law had long allowed warrantless arrests "where delay would be perilous. Necessity is the first law of government as well as of nature, and it is not to be abrogated by implication."[60] The court contrasted Powers's arrest with the English tradition of issuing general warrants, which allowed arrest without suspicion.[61] Very clearly, the court held, Powers's case was not one where he was singled out for arrest without any suspicion of wrongdoing.[62] Further, by the way Redfield characterizes Powers's arrest, it could be justified under a sort of "exigent circumstances" exception to the warrant requirement.

The chief justice dismissed the remainder of Powers's arguments by noting two things. First, the privilege against self-incrimination and the right to a jury trial both apply only in the criminal setting.[63] The privilege against self-incrimination arises when a person might be compelled to give evidence or testimony that might expose him to criminal liability, and the right to a jury trial arises when a person could be subjected to jail, fines or some other penalty.[64]

Redfield readily admitted that Powers's initial jailing could be considered punishment, but for the chief justice, the similarity was superficial. The liquor law, he wrote, "provides that if one shall be in that peculiar state of intoxication, whereby his conduct puts those about him in reasonable fear of bodily harm, any sheriff, or other officer named, may take him into custody, and detain him till [he] is sober enough to testify."[65] For the court, imprisonment under these circumstances is not punishment for an offense but is instead for the prevention of other offenses. "No man ever supposed that every time a policeman arrested a night-walker, or a drunken brawler, in New York or London, he was violating the chartered rights of the citizen or subject, in the manner claimed here."[66]

The right to a jury trial protected by the Vermont Constitution,[67] Redfield explained, did not extend to "all mere police regulations" or to minor offenses.[68] He noted laws had long existed, in various forms, to protect against drunkenness and its consequences, and those laws had never been considered constitutionally suspect for failure to provide for a jury trial.[69] Indeed, Redfield expressed concern that if the liquor law was declared void for failure to give a jury trial, then in principle, all minor police regulations and lesser offenses could be considered constitutionally infirm.[70] Assuring

his readers that the right to a jury trial was secure in cases in which a person could be imprisoned in the state penitentiary, Redfield held the Vermont Constitution did not guarantee the right to a jury trial in circumstances such as those that led to Powers's incarceration.[71]

As to the privilege against self-incrimination, Chief Justice Redfield hardly considered the right in jeopardy. The statute, he wrote, does not compel a person to give evidence that put him in jeopardy of a fine or jail but was more like preliminary proceedings—such as an inquest or grand jury inquiry—against another person.[72] The court found nothing in the statute that violated Powers's constitutional rights, and it ordered him to remain in jail.

For Powers, the result was no doubt disappointing, and one wonders whether he decided to testify against whoever sold him the liquor that made him yell so abusively at his father. Powers's case marked the beginning of a very interesting period of Vermont constitutional law, one that has implications for cases argued today, particularly in the search-and-seizure setting.

3

SKIRTING THE LINE

Southern Vermont in the eighteenth and nineteenth centuries had very little history of breweries. The only real record of a brewery in the Brattleboro area was a passing notice in the *St. Alban Messenger* that stated, "Robert Masterton's brewery, at West Brattleboro, was badly damaged by fire Monday night, but all the contents of the vaults and basement of the building were saved; insured for $3000."[73] It is not known if the brewery was restarted.

Bellows Falls has a rather enigmatic brewing history in Vermont. The earliest record of a brewery in the town was an 1854 record from the Vermont legislature stating that Frazier and Billing, brewers in Bellows Falls, had stopped their brewing operation to comply with the new prohibition law passed in 1852.[74] While no information has been found on the extent of their brewing operation or when the brewery started, a case in Vermont State Supreme Court mentions the operation of a gristmill in Bellows Falls by Frazier and Billing dating from September 1837.[75] With access to a gristmill and presumably a malt house, a brewery would have been relatively easy to launch. Frazier and Billing had hoped to get approval to resume brewing and "to draw it mild," but the house chose to send the petition for review to the committee on the liquor law. No further mention of Frazier and Billing resuming their operation was made. Mr. Powers of Woodstock, who introduced a resolution on the house floor on behalf of the brewers, lauded their efforts to reopen their brewery as an example of how brewers could go about their own operations while still respecting the law.

Another well-documented Vermont brewery from the late nineteenth century was not actually located in Vermont but across the bridge (and state line) in Walpole, New Hampshire. Owned by Alvah Walker (Boston, Massachusetts) and Henry Blake (Bellows Falls), the brewery first started production in 1876 as Walker, Blake, & Co. The brewery lasted for about three years, changing its name to Fall Mountain Lager Company and adding H.H. Dewey (Bellows Falls) to the rolls of the ownership from 1879 to 1886. From 1886 to 1893, the brewery was called the Bellows Falls Brewing Company. After first using the name Bellows Falls Brewing Company, the brewery became the Mountain Spring Brewing Company from 1893 to 1895. After Mountain Spring, the name was changed to New Mountain Spring Brewing Company from 1895 to 1900. New Mountain Spring became Crescent Brewing Company from 1900 to 1902 and then reverted back to the New Mountain Spring Brewing Company from 1902 to 1904. In 1904, the New Mountain Spring Brewing Company became the L.J. Vetterman Brewing Company for a few short months before becoming the Manilla Brewing Company from 1904 to 1907. What started as Walker, Blake, & Co. in 1876 ultimately stopped all production in 1907.

Walker purchased the land with the intention to start a brewery from the start. The land on which the brewery was situated ideally—it was a half mile from the Cold River Railroad Station and near a large water supply from the Cold River, as well as springs from Fall Mountain, noted as being some of the purest in New England at the time.[76] The land was purchased from Joseph Wells a couple years prior to the construction of the brewery in October 1876. After purchasing the land, Walker waited nearly two years before breaking ground to see the condition and volume of the water sources through the different seasons. As it happened, 1876 was one of the driest years on record in the region, but while the Connecticut River was low and many wells in the area dry, the water supply on the parcel of land Walker had bought barely changed. With this assurance of the water supply, construction began. By January, the brick exterior of the main building with a thirteen-foot-deep "lagering" vault had already been constructed. The main building was roughly four stories with twenty-inch-thick brick walls and nearly seventy-six by sixty-four feet in stature. The walls and floors were reinforced with wrought iron. The lagering vault held upward of seventy large casks with each cask capable of holding forty barrels of lager. The fermentation room had an astounding twenty-eighty barrel fermenters. Although the building was large enough to start off the operation, the building proved to be too small. A later addition of seventy-five by thirty-

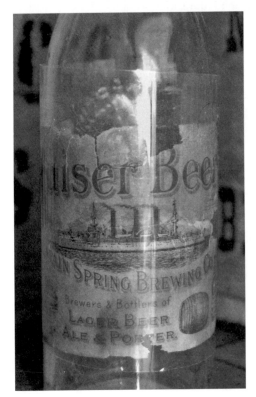

Above: Mountain Spring Pilsner from Walpole, New Hampshire, circa 1880. *Collection of Toby Garland, photo by Kurt Staudter.*

Left: Cruiser ale from the Mountain Spring Brewery in Walpole, New Hampshire, circa 1890. *Collection of Toby Garland, photo by Kurt Staudter.*

three feet was added to the main building while an icehouse and a cottage for the brewers were built on the surrounding land. The first brewer was Charles Kellor, an immigrant from Bavaria, Germany, who oversaw the operation and produced a well-regarded lager.

With the Fall Mountain Brewery changing over to the Bellows Falls Brewing Company, the brewery also changed its brewing style. The lager that the brewery was producing gave way to traditional ales. The brewery produced the "Duplex Ale" with one particular label showing that William Miller in Montpelier, Vermont, bottled it. The bottle was labeled for "Export Only" to be sold outside the state. It was thanks to the brewery's location over the Connecticut River in New Hampshire that allowed it to function relatively unscathed by Vermont's suffocating prohibition law. The addition of export only and the name Bellows Falls Brewing Company also indicate the steps the owners were taking to have the beer in the Vermont market place.

The brewery in Walpole had a rather shocking but not uncommon accident in 1879. In January, F.P. Hadley, a prominent citizen of Bellows Falls and a dealer of stoves, was attempting to repair an issue with the hot water system and fell into the hot water tank up to his waist. Hadley was so severely burned that when help arrived and attempts were made to remove his clothes, all of the skin from the waist down came off his body. Hadley succumbed to his extreme injuries a few days later.

In the 1850 manufacturing census of Vermont, Peterson was the only listed brewer in the state. From the census records, he produced eight hundred barrels of beer in 1850 using two thousand pounds of hops.[77] Some local histories (such as Quechee's and Hartland's) claim that there was a brewery that was replaced with a church or meetinghouse, but these histories require further investigation.

The last attempt at starting a brewing operation in Burlington before federal Prohibition was in November 1906. A bill before Mr. Senter, the representative for Montpelier and chairman of the committee of corporations, to create a new brewery in Burlington was removed from that committee and sent over to the committee on temperance for consideration before any ruling could be made by Mr. Senter's committee.[78] Needless to say, the bill was left to quietly wither away without anyone to further notice in Montpelier.

While Vermont does not have such a large volume of historic breweries, beer produced outside Vermont always found its way into the state. As early as 1804, advertisements started to appear in Vermont papers proclaiming

A very rare bill of sale from the Burlington Brewery owned by William Stone. *Courtesy of Toby Garland.*

the availability of ales of varying styles and from various places. In a June 13, 1804 advertisement from the *Middlebury Mercury*, porter/brown stout, mild ale and burton ale were available bottled by the hogshead or dozen. It is important to note that the porter and mild ale were the same cost, twenty-seven dollars, while the burton ale cost thirty-two dollars. In this case, the ales were sold by Thomas Byrd of Vergennes and Thaddeus Tuttle of Burlington but were from the Old (or St. Roc) Brewery in Quebec, Canada. In Windsor, Vermont, A&S Wardner had strong beer from New York available for sale in 1820.[79] The same year across the state, Luther Hagar had strong beer for sale by the barrel at the Stone Store in Middlebury.[80] Advertisements through 1830 in numerous papers around the state proclaimed the availability of Philadelphia porter, burton ales and strong beer from different states. The first appearance of India pale ales—aggressively hopped ales that have an increased alcohol by volume and hop content to withstand the long voyages to India from England—curiously first appeared in Vermont in 1856. In the beginning of state prohibition, Samuel G. Studley, formally partnered with S.S. Pierce and successor to J.B. Parker, advertised that he had for retail or wholesale casks of different beers, including "Alsop's India Ale."[81] Advertisements and labels for Pabst, Schlitz and other nationally known beers are found in Vermont papers through the late nineteenth and early twentieth centuries.

The importation of different beers into Vermont in casks brought the rise of another industry: bottlers. Bottlers in Vermont brought all types of beers into the state, bottled them on their own equipment and placed printed labels with the brewers' names and their names, listed as the bottlers, on them. In Vermont in the late nineteenth century during state prohibition, bottlers brought in beers that were under the alcohol limits set by state law, although this appears to have been a practice that fell into a gray area of the prohibition law. Bottlers in Vermont bottled mineral water, soda and ciders along with beer. Some bottlers in Vermont during the late nineteenth century were J.E. Lanahan (Rutland), M.J. McGowan (Barre), S.F. Darling (Fairlee), Fowler Bottling Company (Burlington), Frank E. Austin (Barre), the Wilson (Burlington), Fred Fenn (Rutland), Samuel B. Doty (Morrisville) and William Miller (Montpelier). While not all bottlers dealt with beer, William Miller made a name for himself bottling the alcoholic beverage.

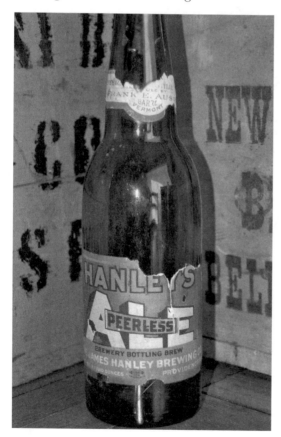

Miller started his bottling business around 1886 as part of a grocery store he operated in Montpelier. His operation was highly regarded for its cleanliness as well as for the purity of the product. Miller's bottling business dealt with ginger ale, champagne cider, soda, birch beer, tonic beer and beer.[82] While by many accounts Miller had a successful operation in

A Providence, Rhode Island–produced beer bottled by Frank Austin in Barre, Vermont. *Collection of Toby Garland, photo by Kurt Staudter.*

Left: A Massachusetts beer that was bottled in Rutland, Vermont. *Collection of Toby Garland, photo by Kurt Staudter.*

Below: Another example of imported beer locally bottled. *Photo by Kurt Staudter.*

Montpelier, he also had problems with the prohibition law. In 1879, before the operation of his store, Miller was found guilty of selling beer and fined $100.[83] Miller's bottling operation and grocery store expanded into a large inn that he operated in Montpelier, where, in February 1892, the saloon he operated and his home were raided. While nothing illegal was found at the saloon, an assortment of bottles and jugs of "panther breath"[84] were found and confiscated from his home.[85] One of the products that Miller was known for was his "Uno," a near beer. This beer, which Miller sold to various outlets throughout Vermont, led to a lengthy court case in December 1895 in Montpelier. After more than sixty-nine hours in deliberation, the jury was out on whether Miller's 2 percent "Uno" beer was in violation of the state's prohibition law. Although it was stated that the case would be tried again, there is no information of a second trial for Miller for his "Uno" beer.[86] When William Miller died in May 1915, his death was noted in papers around Vermont, noting his reputation for high-quality service at the Miller Inn in Montpelier. There was no mention of his infractions with the prohibition law.

William Miller's "Uno" beer did, however, have one more court case in Vermont. In a November 1901 court case, *State v. Charles F. Skeels, John Mulvihill and Clara E. Rodgers*, the operators of a sizeable hotel in Milton were accused of violating an injunction on selling "Uno" beer. It was noted that the "question as to whether Uno beer is or is not intoxicating has come before nearly every court in Vermont and the matter will undoubtedly be decided by this case." The defense brought both the manufacturer of "Uno" beer and a noted chemist to defend the fact that the product was not intoxicating. The creator of "Uno" beer was Fred J. Tabor from Suffolk Brewing Company in Boston, and he had created the recipe over fifteen years prior due to the prohibition laws in Maine, New Hampshire and Vermont. He noted that Vermont was a large consumer of the product. The recipe was a mixture of hop extract, albumen, syrup, yeast and flavoring extracts. The ingredients would be mixed together to achieve the correct flavor, sterilized to prevent fermentation and finally charged with carbonic acid gas for carbonation. Tabor noted that the whole process to make "Uno" beer was about twenty-six hours and that it would be carbonated within four to five days, while malt beer required months from start to finish.

The noted chemist was Professor Henry Carmichael, professor of chemistry at Bowdoin College and formerly of the Boston Institute of Technology. Carmichael noted that he had tested many samples of

"Uno" beer for William Miller of Montpelier and had never found the beer to exceed 2.15 percent. From all the samples he tested, Carmichael arrived at the conclusion that since there was no malt present, he deemed the beer nonintoxicating. Judge J.H. Watson arrived at no decision and dismissed the case.[87]

Brewing in Vermont completely vanished, along with any trace of brewing infrastructure on the landscape, until the emergence of Catamount Brewing and Vermont Pub & Brewery, effectively launching the state's brewing revolution. While beer is currently a focal point of Vermont's economy and has garnered the state international acclaim, the production of the liquid proved to be a magnet for opposing forces of all sorts. The fascinating aspect of the state's brewing history is that the current widespread success has stemmed from the perseverance and vision of a select few in modern times rather than continually building on a rich, established tradition. The next chapter covers the period of Vermont's brewing history, in contrast to its tumultuous past two centuries, when the industry has been celebrated.

4

THE EVILS OF ALE

While the eighteenth century into the very early nineteenth was filled with such names as the syllabub, the flip, the toddy and the sling to describe various alcoholic drinks, by the 1820s, the social climate was rapidly changing in Vermont. Benjamin Franklin had accumulated a couple hundred different terms used to describe drunkenness. New references such as "Demon Rum" and "Devil's Water" started popping up in New England with the temperance lexicon expanding seemingly every day.

The temperance movement—peaking around the time of the Eighteenth Amendment, more commonly known as the Volstead Act, in 1919—had its early roots over a century before with the founding fathers. While some of our nation's founders, such as George Washington, John Adams, Thomas Jefferson and John Hancock, were known for their thirst for and even production of alcohol, Dr. Benjamin Rush had a different view on it. In one of Rush's last writings, his treatise *Medical Inquiries and Observations upon the Diseases of the Mind* in 1812, he brought forth the notion that repeated excess alcohol consumption and uncontrollable drinking was an addiction rather than a simple choice. With the notion that alcohol was an addiction and disease rather than a weakness in morals, Rush put forth the rudimentary framework on how to treat and help recover from the illness.

By the middle of the nineteenth century, the temperance movement had such leaders as John Bartholomew Gough, who would terrorize the gathered crowds with his fiery rhetoric: "Snap your burning chains, ye denizens of the pit, and come up sheeted in fire, dripping with the flames of hell, and with

your trumpet tongues testify against the deep 'damnation of the drink.'"[88] New England was the preeminent hotbed for the temperance movement with Vermont near the center of it.

By 1808, the notion or ideals of temperance had started to emerge on a state level. In an 1808 address of the Council of Censors of the state of Vermont, the lecturer started in closing: "No crime is, perhaps, attended with more evil consequences to society and individuals, than that of drunkenness."[89] There were newspaper articles and reprints that toyed with the notion of temperance. An article in the *Green Mountain Patriot* published on April 4, 1806, reprinted from the *Portsmouth Oracle*, had the headline "More Beer and Less Rum" and noted the expenses a man would incur consuming the "harmful" spirit rather than strong beer.[90] No significant developments occurred in Vermont's temperance movement until the 1820s.

The early temperance movement gained traction in the Northeast Kingdom and the shores of Lake Champlain first. The earliest temperance society in Vermont was formed in 1817 in the Northeast Kingdom town of Ryegate. While other societies started to loosely form in Vermont, the next town to formally organize one was Barnet in the Northeast Kingdom in 1822 with other groups forming closely after statewide.[91] While Middlebury was one of a couple hotbeds in Vermont for the Second Great Awakening—a Protestant religious revival that ignited throughout New England and many points south—the subject of temperance did not catch hold formally until January 1, 1829. While it took longer to formally gain footing, over six hundred residents of Middlebury joined the society in less than two months.[92] Only a few years later, temperance societies sprouted and gained membership in every corner of the state. It took a while for the temperance movement to gain traction in Vermont: "Vested interests and personal habits both prevented any sudden change [in] established customs."[93]

The growing temperance movement in Vermont did find myriad protesters across a spectrum of backgrounds. Some inns and taverns stopped serving spirits to their clientele but still served wine and ale, which in the fledgling temperance movement were still considered "wholesome" beverages, while most inn- and tavern keepers just turned a blind eye to the impending storm. Others took a more radical position on temperance. Luther Torrey, a tavern keeper in Stratton, simply walked away from his business. In Abby Hemenway's opus *The Vermont Historical Gazetteer*, she compiled an account from Elijah Torrey, one of Luther's six sons, that "when the use and sale of intoxicating liquors began to be preached against as sinful, he laid aside his glass, took down his bar and sign and became, thenceforth, a farmer and

lumberman."[94] By the 1830s in Vermont, the transition from taverns and inns to temperance houses and inns was already starting to take affect.

One notable protest against the temperance movement in Vermont was lodged by John H. Hopkins, the bishop of the Protestant Episcopal Church for the Diocese of Vermont. Sometime around 1833, Hopkins published a monograph entitled *The Triumph of Temperance Is the Triumph of Infidelity*. In his work, Bishop Hopkins defended his views by stating how the wines of the Bible and other religious writings were just as intoxicating as the wines of his time. Through that thought process, people observing total temperance were therefore doing the work of infidels.[95] Hopkins's work outraged many temperance leaders and caused quite a backlash. *Letters to John H. Hopkins, D.D., Occasioned by His Lecture in Opposition to the Temperance Society*, published in Windsor, Vermont, in 1836, was produced in opposition to Hopkins's claims. The series of letters contained in the volume were all vehemently against Hopkins's work, but they also question many aspects of his devotion and assumptions on religious grounds. Responses to Hopkins's work can be found from across the country in different temperance societies from the decade that followed.

With the growing strength of the temperance movement in Vermont, temperance houses start emerging throughout the state. Tourism has always been an important part of Vermont's economy, and temperance houses filled a unique void at the time. By offering lodging that was free from the influence or temptation of drink, innkeepers and hotel owners hoped to appeal to customers who would shy away from taverns or "wet" inns and hotels. The notion was well intentioned but not practical since many owners made their profits from serving drinks and beverages. There was a noticeable trend of temperance houses not lasting long in operation due to the competition in surrounding states that served alcohol.

As Vermont's temperance movement was slow to ignite and still smoldering, another New England state's erupted. When Neal Dow was elected mayor of Portland, Maine, in 1851, he was able to get the Maine legislature to pass a law now commonly referred to as the "Maine Law," the nation's first statewide prohibition law. In the law, it became illegal to sell or produce spirits, assigning penalties to anyone who was found to not obey the law. The laws lasted until June 2, 1855, when Dow ordered deadly force to be used at a riot, composed predominantly of Irish immigrants. By the end of the decade, Maine had reversed its statewide prohibition.

5

TEMPERANCE

While Maine repealed its prohibition law, Vermont was a different story. The first attempt at a form of state prohibition was the first version of Act 24 that was passed by the General Assembly of Vermont on November 3, 1846. The first incarnation of Act 24 targeted the operation licensing of innkeepers and retailers in the state. The act allowed a statewide vote each March, beginning in 1847, to decide whether to allow licenses to sell alcoholic beverages. The first vote resulted in a 21,798 to 13,707 win to ban licenses. Only Essex County voted to keep issuing licenses for the sale of alcohol.[96] This vote left the state of Vermont essentially a "dry" state with the exception of Essex County, although the ban was by many accounts a symbolic one and not readily enforced. The March 1848 vote returned the state into the "wet" ranks once more. The temperance vote succeeded once more in 1849 and 1850 to turn and keep Vermont "dry." Eventually, the temperance movement was able to get the General Assembly to pass Act 30 on November 13, 1850, which permanently banned the licensing of alcohol for beverage purposes and removed the yearly state referendum.

The Vermont state legislature passed its version of an overall encompassing state prohibition in 1852 that was officially ratified in 1853. At the time of the debate over the state prohibition law—Act 24 as it was known—in Montpelier there was a very deep facture over the question of manufacturing alcohol. The act passed the house by a vote of 91 to 90 on November 23, 1852. Act 24 was presented to voters on the second Tuesday of February 1853 to choose the date that Act 24 would be in effect. The two dates were

either the second Tuesday of March or the first Monday of December 1853. The state vote resulted in 22,315 to 21,794 to enact the earlier date as the starting date of Act 24. The voting fell along a geographic split with all western counties voting for the earlier date and all eastern counties, except Caledonia, approving the later one. Almost immediately, the House of Representatives questioned whether to repeal the law.[97] No serious action was undertaken to try to dislodge the law in the decade that followed.

Under Section 18 of Act 24, or "the liquor law of 1852," a passage establishes that cider and other fermented beverages essentially for home use would be permissible as long as the beverage never made it into the public domain: "Provided that nothing in this chapter contained shall be construed to prevent the manufacture, sale, and use of cider, nor the manufacture by any one [sic], for his own consumption and use, of any fermented liquor: Provided however, that no person shall sell or furnish cider or fermented liquor at or in any victualling house, tavern, grocery shop, or cellar, or other place of public resort." The same section also stated that "nor shall any person sell or furnish cider or any fermented liquor to an habitual drunkard under any circumstances." The penalty specifically for giving a fermented beverage to a "habitual drunkard" was ten dollars paid to the state treasurer. One could, however, give and consume alcohol in one's own home as long as it did not lead to intoxication.

There were some loopholes in the law. One such example is that "nothing in this chapter [94] shall be construed to prevent the manufacture, sale, and use of the fruit of the vine for the commemoration of the Lord's Supper." Other such loopholes in the early version of the law did little to stop the consumption or production of hard cider, only restricting the ability to sell it. Cider at this point was an important aspect of the Vermont landscape. Easily produced, it was a cornerstone of most families' cellars for a long winter. Numerous accounts around the state from 1790 to 1830 mention the storage of casks or barrels of cider for the long winter. Amounts widely varied from a few barrels to upward of forty. This is certainly reflected in the early version of Vermont's prohibition law. Later amendments close the usage and production of hard cider, placing it in the same realm as strong beer and spirits.

The political fallout of prohibition was lasting though. Governor Erastus Fairbanks, a Whig, was up for reelection in 1853 and failed to gain a majority vote. The General Assembly elected John S. Robinson, the Democratic runner-up, ending a nearly twenty-year run of the Whig party holding the governorship. Robinson served only one term, succeeded by Stephen

Royce, who served two terms as governor. He was elected as a Whig but was reelected as a Republican, having abandoned the Whig party. The Republican Party in Vermont was formed in 1854 and went on to hold the governorship for one hundred years while the Whig Party effectively disappeared from political view.[98] While other political factors were afoot, the ratification of state prohibition in Vermont led to the nearly meteoric fall of the Whig Party in the state.

Act 24 was able to firmly stay embedded due to the confluence of religious fever and a changing political landscape. At the time of the passing of Act 24, the Second Great Awakening had already climaxed in Vermont, and the momentum of prohibition was furthered from the emergence of the Third Great Awakening. The Third Great Awakening's sweep through New England and specifically Vermont created a sociopolitical climate that precluded any formal political pushback against prohibition. This atmosphere existed through the end of the nineteenth century with some Vermont towns seeing churches erected on the former sites of taverns just after the Civil War.

The temperance movement led to rather unique court cases in the late nineteenth century in Vermont. The most puzzling case to occur was a May 1876 case in Rutland, Vermont, that was known as "the *State of Vermont v. One Keg Of Lager Beer.*" The theatrical event, although handled by an actual justice and attorneys, was not a legitimate case.

The keg of lager at the heart of this argument was seized on May 8, 1876, at a German café in Rutland operated by Frank Jackson. The case came before Justice H.W. Porter at the office of Prout, Simons, & Walker on a Saturday morning. It was noted that there was a rather high amount of fanfare for such a unique event. Within the early portion of the hearing, many questions were asked to determine what level of "exhilarated" a man must be to be considered intoxicated. One case of hearsay presented to Justice Porter was a man living in Rutland who consumed 137 glasses of said lager in one evening and did not feel any "exhilarating" effects observed by witnesses. Surprisingly the man could not be located for the hearing.

A jury was brought in the courtroom with L.W. Redington as counsel for the state and Prout, Simons & Walker and W.H. Smith representing the defense. Jackson claimed that the keg of lager was not for sale and was nonintoxicating liquor. The lager was tested and found to contain 6 percent alcohol. The doctors who presented this evidence also presented a comparison of two-year-old cider that contained 8 percent alcohol, Bass ale

at 6 percent, lager seized from A.R. Fuller at 8 percent and a porter ale at 4 percent, all of which were deemed in the state statute as intoxicating.

The defense objected to the comparisons on the basis that the case at hand was on this keg of lager seized in Rutland, not any of the other drinks presented. The first witness for the prosecution was Dr. E.C. Lewis, who was one of the doctors who tested the lager on the day of the seizure. It was revealed that the doctors who analyzed the sample on the day of the seizure had drawn different alcohol percentages ranging from 5 to 6 percent. Lewis testified that lager, after being left open, gradually loses alcohol content, turning into vinegar. The next witness was Dr. Lorenzo Sheldon of West Rutland, who testified he had no knowledge of the intoxicating properties of lager nor had he ever witnessed someone he knew drink lager. The third witness was Dr. S.H. Griswold, who presented the same testimony as Dr. Sheldon.

The next witness was Oscar Phillips of Rutland. The reporter for the *Rutland Daily Globe*'s take on the witness was that "he had drank [*sic*]; had drank [*sic*] a good deal." He recalled in his testimony that when he drank lager in Saratoga, New York, he had never gotten intoxicated off lager alone. He had consumed lager all night and felt nothing more than a touch "light-headed" and rather full. Phillips was not cross-examined, but the counsel for the defense remarked that Phillips was "light-headed" when he started his testimony.

The last witness for the prosecution was William Powers, who testified that he had consumed lager beer years ago in New Haven, Connecticut, and the lager he had consumed had left him intoxicated for six hours afterward.

The defense then had its turn. Its witnesses were sworn in, all doctors. The *Rutland Daily Globe* reported, "The array of ponderous experts sitting opposite the jury in a body was really quite imposing."

The first witness for the defense was Dr. E.A. Pond. Pond had analyzed the same lager beer and found it to contain 4.6 percent alcohol. He went on to explain to the courtroom that he had spent considerable time studying lager beer and found that the beer was made from only barley and hops and contained a small amount of alcohol, considerable sugar and other compounds. Pond continued that lager beer was a powerful diuretic and, taken in large amounts, was cathartic, quite nutritious and nonintoxicating. His closing remarks were that "a man may drink 15 to 20 glasses, and aside from feeling a little sleep or stupid, feel no effects from it; it is carried away before the system has time to absorb alcohol enough to intoxicate."

The next witness was Dr. Middleton Goldsmith, a doctor who studied and spent time in Germany. Goldsmith agreed with Dr. Pond on all the properties

of lager, though he went on to relay his experiences in Germany and many lager beer gardens. One garden in particular had nearly thirty thousand people (including Goldsmith), according to police reports, who consumed lager all day, and at the time of the closing of the beer garden, Goldsmith went to the exit and observed the crowd leaving. He noted that there were only two people who showed any effects—both fourteen and fifteen year old girls. He closed his testimony noting that, in European countries that are known for their brandy and whiskey, the drunkenness is extremely high, while in Germany, where lager is consumed, there is a very low amount of drunkenness. Goldsmith also testified that he had consumed lager beer in Jackson's establishment and found it nonintoxicating.

The next five doctors all testified similar arguments to Dr. Pond's. The last witness called to the stand was Dr. J.D. Hanrahan. He testified that he lived near the entrance of a sizeable lager beer garden in New York and saw huge quantities consumed. He even admitted that he "frequently drank from twenty to thirty glasses in one evening and felt no effect from it." He closed his testimony that, in his opinion, he did not feel that any "man or woman with any brains could drink enough to become intoxicated."

After the witnesses were heard, the court adjourned for an hour for dinner. At two o'clock, the court was reconvened, and the lawyers made their closing arguments. The court left the jury to decide the matter. In five minutes, it was noted the jury had reached a decision. The verdict found that lager beer was "not guilty" of all charges in Vermont.[99] This verdict and case was noted in other states in the preceding years. It is unclear if lager beer ever was fully banned under prohibition since advertisements for lager beer appear in newspapers in Vermont through the end of the century.

Vermont's statewide prohibition came to an end as a result of the 1902 gubernatorial election. Percival Clement, a prominent businessman from Rutland whose business interests included ownership of the *Rutland Herald*, ran as an independent with a big part of his platform to abolish statewide prohibition and allow the local option to return. Although Clement lost the gubernatorial election of 1902 (ultimately winning the post in 1919), his efforts led to the December 11, 1902 passing of Act 90. The act returned the vote on prohibition to the annual March town meetings, which this time would be to vote not only on "wet" or "dry" but also the types of licenses that would be issued for alcohol sale. A referendum was held on February 3, 1903, to vote on the effective date, either the first Tuesday in March 1903 or the first Monday in December 1906, the latter being three years later to place the responsibility on the next administration. The March 1903

date won by a vote of 29,711 to 28,982. While statewide prohibition was effectively lifted, many counties and towns remained mostly dry through federal Prohibition.[100]

Scott Wheeler best sums up Vermont's temperance and prohibition in the epilogue of his *Rumrunners & Revenuers: Prohibition in Vermont*: "After all, Vermonters themselves had voted to keep the state 'dry' for all but one year between 1847 and 1903. It would be more truthful, though, to say that the state was 'damp,' as the law was loosely enforced and often disregarded."

Federal Prohibition saw Vermont once again return to being "dry." With the ratification of the Eighteenth Amendment on January 16, 1919, a dark version of Prohibition arrived to the state. While the previous decades had seen Vermont as a leader of temperance on the surface, beer consumption was still very much present. With locally produced small beer and lager for a period, "Uno" beer and imports, Vermonters still enjoyed their beer. The onset of federal Prohibition brought a steady stream of unsavory characters through the state to Canada to run Canadian beer and whiskey back to such cities as New York, Boston and Hartford. Places like Barre, Vermont, became hubs for the distribution of illicit alcohol from Canada, and places like Derby Line, Vermont, became renown throughout the Northeast for their "line houses," where someone could walk through the front door in Vermont and enjoy drinks in the Canadian portion of the home. Even after the repeal of the "Noble Experiment," Vermont was a wasteland for locally produced beer for many decades to follow.

6

VERMONT'S BITTER CROP

Through the rise of temperance in the 1830s to the 1852 state prohibition law and for a decade after, Vermont's agricultural gem was hops, the same plant that is quintessential to the production of beer. While Jordan Post of Vergennes made reference back in 1793 on sourcing hops locally, the cultivation of hops became commercially viable on a large scale around the 1840s in Vermont. The growth of hops production in the state of Vermont ran parallel to the rise of the temperance movement. It is rather ironic that while the brewers, distillers and tavern keepers were targets of the temperance movement, farmers were never mentioned as a source of the "scourge" of intoxicating drink, even though hops had only one purpose.

The cultivation of hops in Vermont became commercially viable statewide around 1840. Prior to 1840, cultivation was highly localized around the state with areas such as Middlebury, Vergennes and Burlington producing the crop locally possibly as far back as the last decade of the eighteenth century. The first documented statewide crop was recorded in the 1840 state agricultural census, which reported that Vermont produced a total of 48,137 pounds of hops. Vermont's 1840 crop accounted for 3.9 percent of the national production, which was dwarfed by New York's production. Windham County produced 25,911 pounds of hops, more than triple the production of any other county in the state. It is important to note that other eastern counties of Vermont—such as Orleans County, which produced a mere 642 pounds—had rather miniscule production.[101]

A decade later, the 1850 crop saw the peak of Vermont's hop production against the national numbers: 288,023 pounds of hops produced statewide, accounting for 8.2 percent of the national crop. Once again, Vermont was dwarfed by New York's production. In the decade since the 1840 agricultural census, Windsor County had become the largest producer, totaling 79,700 pounds; Orleans County was second, producing 77,605 pounds; and Windham County dropped to a distant third with 41,510 pounds.[102] It is important to remember that, in 1850, there was only Peterson's brewery in Burlington consuming hops, leaving the entire crop to be exported out of the state. An example of how the temperance movement was carrying over to the agricultural side by the 1850s comes from a news post in the *Rutland Herald* from November 24, 1854. The brief post notes, "A writer in the *Vergennes Independent* is opposed to raising hops as every ounce of hops will make beer enough to get a man drunk."

The agricultural census of 1860 showed the peak of the hop-farming boom in Vermont. Statewide, a total of 638,657 pounds of hops were produced, nearly triple the numbers reported just ten years prior. Orleans County produced 161,192 pounds of hops, nearly 40,000 more pounds than Windsor County. Some of the interesting trends that occurred in the 1860 census were that every county in the state was actively producing hops. This included Grand Isle and Chittenden, which both produced around 2,000 pounds. Bennington County tallied a mere 8 pounds.[103] The large increase, however, only accounted for 5.8 percent of the national crop, a drop of 25 percent from the previous national contribution. This decrease in Vermont's production against the national production highlights the addition to the national output from Midwest and Pacific Northwest growers. As these areas expanded and improved production, Vermont's production became less important to the market.

By 1870, signs of the impending decline of the Vermont hop crop started to occur in the census records. Vermont produced 527,927 pounds statewide, a noticeable decline from the previous record, accounting for only 2.1 percent of the national crop. Windsor and Windham Counties started to decline in their production, while Orleans doubled production, accounting for nearly half of the entire state's production. Bennington County had no recordable amounts, while Chittenden County produced only 1 pound. Rutland County saw the largest decrease, dropping from 21,835 pounds in 1860 to 400 pounds in 1870.[104]

The Vermont state agricultural records for 1880 and 1890 show drastic drops statewide, with Derby, Vermont, the last sizable producer of hops in

the state. The 1900 agricultural census for Vermont recorded only 4,400 pounds of hops in the entire state.[105] The end of Vermont's hop industry came quietly as the industry disappeared from the public record, along with any trace of the infrastructure that supported this once booming enterprise.

Historic Recipes From Vermont

Spruce Beer Recipe

First, procure a new cask, and a sufficient number of junk bottles, to contain as much as the cask will hold; Then take in proportion of one pint of essence or extract of spruce to 24 gallons of water, and 4, 5, or 6 quarts of molasses, as you like it best, and shake them well together, some grounds of beer or porter, must be added to the first brewing, in order to excite the fermentation; let the cask be made quite full that the yeast may be cast out at the bung. If the weather be pretty warm cold water will answer as well as warm; but if the weather will be cold it will be best to warm the water a little, it will generally be sufficiently worked in less than 24 hours, as soon as the fermentation abates the cask must be carefully corked, or the beer drawn off immediately into junk bottles and corked so as to perfectly exclude the air, or otherwise the beer will prove flat and lifeless; let the bottles into a cool cellar and the beer will be fit for use in three days; but will grow better by keeping. Throw all the grounds out of your cask and cork it up and let it bye till you want to brew again, keep it carefully stopped and it will not turn sour or musty, and will be sufficient to excite a fermentation in any subsequent brewing.[106]

Maple Beer Recipe

To every 4 gallons of water (while boiling) add a quart of maple molasses. When the liquor is cooled to blood heat, put in as much yeast as is necessary to ferment it. Malt or bran can be added to this beer, when agreeable—if a tablespoonful of the essence of spruce is added to the above quantities of water and molasses, it makes a most delicious and wholesome drink.[107]

Hop Beer

For a half-barrel of beer take half a pound of hops and half a gallon of molasses; the latter must be poured by itself into the cask. Boil the hops, adding to them a tea-cupful of powdered ginger, in about a pailfull and a half of water, that is quantity sufficient to extract the virtue of the hops. When sufficiently brewed, put it up warm into the cask, shaking it well in order to mix it with the molasses. Then fill it up with water quite to the bung, which must be left open to allow it to work. You must be careful to keep it constantly filled up with water whenever it works over. When sufficiently wrought to be bottled, put about a spoonful of molasses into each bottle.[108]

Small Beer (1804)

As we are coming to the season for hot weather, in which nature calls for drink, and there has been a difficulty to keep small beer from souring in the hot weather in two or three days, by which, necessity obliges to make more use of spirituous liquors than persons would otherwise choose, it may be useful to communicate to the public a method for brewing good wholesome small beer, which will not sour, namely.

Take two ounces of hops, and boil them three to four hours in three or four pails of water; then scald two quarts of molasses in the liquor, & turn it up into a clean half barrel, boiling hot; then fill it up with cold water; before it is quite full, put in your emptyings [yeast] to work it, (the emptyings it will produce will work beer from time to time) the next day you will have agreeable wholesome small beer that will not fill with wind as that which is brewed from malt and bran; and it will keep good till it is all drank [sic] out. I have practiced this method for about a year in my own family, and find it very useful.

Gentlemen, Yours.[109]

ECONOMICAL, New METHOD, of making BEER (1799)

A member of the Chymical Society of Philadelphia has discovered that the shells of Green Pea, which are at present thrown away as useless, make excellent beer and good spirit.

The process is to pour 6 gallons of water on one bushel of the shells of peas, and boil the whole until the shells are insipid to the taste. Pour off the water, which will be very sweet, into a clean tub or keg and add to it a pint of yeast and two ounces of ginger in powder. In a short time fermentation will take place and when it is complete, the beer will be fit for use.

Beer obtained in this manner is very clear, has a fine amber color, is pungent to taste, when poured into a tumbler, bears a fine bead, is superior to common molasses beer, and is not inferior to mead.

One bushel of the shells of peas, will make several dozen bottles of beer. The beer should be put into strong bottles, and the cork should be secured with wire. If the cellar is not cool, the bottles will burst with an explosion, as the author of this communication has experienced.

The beer distilled yields spirit, of the taste and color of whiskey.[110]

PART II
A BREWING REVOLUTION

FROM THE HUMBLE BEGINNINGS
OF HOMEBREWERS

What a difference a century can make: Vermont went from one of the first states to embrace the temperance movement to the state with more breweries per capita than anywhere else in the country. There are many explanations for this, but perhaps the easiest way to understand how it happened is to explore all the wonderful breweries. Vermont has a long tradition of supporting local growers and the artisans who add value to the agricultural products they produce. Long before there was a locavore movement, long before farmers' markets became chic and long before other parts of the country embraced the idea that food produced where you live is better, the frugal and pragmatic Vermonters had this figured out.

So when the likes of Steve Mason, Greg Noonan, Andy Pherson, Lawrence Miller and Ray McNeill started brewing handcrafted beers in every corner of the state, Vermonters had a pent up thirst for as much as they could produce. The locals were quick to embrace these guys who were taking their passion for good beer and bringing us styles of beer long forgotten by the large industrial brewers.

There was a time during the late 1970s when business majors were taught about how capitalism worked through the example of the consolidation of the brewing industry. Before Prohibition, there were thousands of neighborhood breweries that crafted small batches of beer that captured a local flavor and could only be purchased within a small region. These beers were rich in the varying number of styles, and each brewery had its own

idiosyncrasies. Everywhere you went, the locals were fiercely loyal to their hometown brewers.

Just after Prohibition, we saw an explosion in the number of breweries, which was to be expected, but then there was a consolidation in the industry. By the late 1970s, industry analysts were predicting that there would be just a handful of megabreweries that all produced the same golden lagers that had become synonymous with American beer. The trend by the 1980s was for beers to become even lighter and less flavorful. "Lite" beers with corn as an adjunct still dominate the domestic beer marketplace today.

It wasn't like you couldn't find good beer; it was just getting harder to do. Beers from Germany, Ireland and England that were packed with flavor could be had at a premium if you could find them, and there were still some small independent breweries left with local followings that kept their unique brands alive. Then something happened that was a game changer. Under President Jimmy Carter, Americans were relieved of a few of the restrictive post-Prohibition regulations that restricted small brewers. Along with Senator Alan Cranston of California, the Home Wine & Beer Trade Association would help craft a law that permitted homebrewers to make one hundred gallons of beer per person or two hundred gallons per household. In February 1979, legal homebrewing was born.

The regulations that were changed created a demand for ingredients, and Americans jumped at the chance to brew their own beer. So when folks visited Europe and tasted all the wonderful diversity of the local breweries, they came home with the desire to re-create those beers. Early on, there were no homebrew shops or books that would hold your hand through the art and science of brewing. Quality ingredients were hard to find, and many batches were best described as "failed experiments." Yet unless they were downright awful, you still drank what you made with the pride of having made it yourself, even if it left you somewhat worse for the wear the next day.

It is these homebrewers who embraced other changes in the rules that made it possible to get laws changed in their states and to start small breweries. Many would be encouraged by friends and family to brew professionally after being amazed by what they tasted; others would take a more traditional route through brewing schools here and in Europe, and some were able to do it the way the craft has been handed down since the beginning of time by apprenticing under a brewmaster.

Then these brewers went to their state lawmakers to get changes in the local laws to permit beer to be made where it was consumed. This is the story of how Vermont has gone from homebrewers on a quest for the perfect pint to a premier destination for beer tourism. Given Vermont's history with the temperance movement and the fact that we began the twentieth century without a single brewery, it is ironic that, as we enter the twenty-first century, it is our world-class beers that have attracted international attention.

The following sections are organized based on the date each brewery first provided beer to the public. In the titled sections, we bring you up to date on what major milestones the various breweries reached during the stated timeframe. While this seems to jump around quite a bit within the timeline, we hope it is a more enjoyable presentation of the material.

Noonan and Mason

Perhaps it is only fitting that the modern history of brewing in Vermont starts with Greg Noonan and Steve Mason. No one more so than Greg embodies the spirit and drive that is at the center of the brewing revival in Vermont. He was essentially a frustrated homebrewer who kept looking to make better beer. He had a knack for book learning, reading everything he could get his hands on about brewing, and almost singlehandedly gave birth to a generation of brewers with his infectious enthusiasm and gentle encouragement. Steve Mason was another enthusiastic homebrewer who dreamed of one day opening a brewery. Learning all he could from the published material on the subject at the time, he took his interest to the next level by doing it the old-fashioned way—he packed his bags and started an apprenticeship in England. Steve Mason would come back to create a business that would introduce Vermonters to the first locally made beer in over a century.

BREWING LAGER BEER: THE MOST COMPREHENSIVE BOOK FOR HOME- AND MICROBREWERIES

Greg Noonan was frustrated by the lack of information on brewing for serious homebrewers. When homebrewing was made legal in 1979, there were a few British companies that jumped into the market with kits and supplies. These kits contained extracts that would be mixed with water to form the basic wort from which all beer is born. From his research, Greg learned that real beer didn't come from kits but from raw ingredients. He was fond of telling a story about his early attempts at purchasing the materials for an all-grain brew. The small homebrew supply store started out refusing to sell him the grains because it would be a waste of money, but Greg insisted and brought his twelve pounds of grains home. Greg would laugh telling of the mess that was created while mashing grains that had been ground in a coffee grinder and trying to sparge the grain dust/mud through a cheesecloth over a bucket.

Not satisfied with the books that were available, Greg did what was typical for him: he started to research his own book. After pouring over professional literature on the subject of brewing, he wrote what is considered by many to be the most concise text on not just lager but all brewing. It is said that there isn't a serious brewery in the United States that doesn't have a wort-stained copy of *Brewing Lager Beer* somewhere in the brewery. It is the go-to book for amateurs and professionals alike.

Greg wrote the text, collected the manuscript in a shoebox and gave it to Charlie Papazian of the American Homebrewers Association at a conference in 1984. Papazian also went on to write a book that changed homebrewing forever—*The Complete Joy of Homebrewing*. *Brewing Lager Beer* was the first book published by what eventually became the Brewers Association, and a revised edition is still in print today.

With the book finished, getting better at the art and science of brewing and becoming a regular contributor to brewing publications, Greg and his wife, Nancy, turned their sights toward opening a brewpub. In the meticulous way

Opposite: Catamount and Vermont Pub & Brewery ads from the first *Yankee Brew News*. *Photo by Kurt Staudter.*

Vermont's Fresh, All Natural Beer

Brewery Tours
Summer-Fall 1990
(5/25 thru 10/29)

Fri. 11:00, 1:00 & 3:00
Sat. 11:00, 1:00 & 3:00
Sun. 1:00 & 3:00
Mon. 11:00 & 3:00

Catamount Brewing Company
58 South Main St.
White River Jct., Vermont
802-296-2248

CRAFT BREWERS

BURLY iRiSH ALE
KELLERBIER LAGER
SMOKED PORTER
PESKY SARPENT
PILOT ALE
DECEMBERFEST
WINTER ALE
british bitter
Rock Dunder Brown Ale
Billybuck Maybock
GRAND SLAM BASEBALL BEER
diving duck sourmash
GABRIEL SEDLMAYER FEST

that Greg did everything, he started thinking about locations, financing and how to build something that no one else was doing on the East Coast—well, almost no one else.

CATAMOUNT BREWERY

February 1987

There is no doubt that the renaissance in beer making in Vermont has sprung from the roots of homebrewing. After the laws changed, there were more and more folks that became interested in making their own beer. Some came home from Europe with a craving for quality beer, while others were interested in the art and science of brewing. Around the same time, stores were opening up that catered to the hobby brewer. Ingredients were hard to come by, how-to books didn't exist and small-scale brewing equipment was something cobbled together with what you had lying around; but what these enthusiasts lacked in raw materials they more than made up for with passion and that good old Vermont ingenuity.

On a trip to Europe, Steve Mason was astonished by the diversity and flavors of the beers he had while traveling. In 1975, he began to homebrew in order to re-create some of those beers. Brewing became a passion for Mason as he perfected recipes and shared his beers with friends and family.

By 1983, Steve Mason had decided that he wanted to brew beer as a profession, and he traveled back to England to apprentice at the Swannel Brewery in Hartfordshire.

That is where he learned what he needed to know about the operation of a commercial brewery. Along with musician Alan Davis and businessman Steve Israel, Mason wrote a business plan in the fall of 1983. They began to look for a place to build a brewery, put together financing and find equipment. White River Junction was picked for, among other things, the mineral content of the water—it was close to the water at Burton-on-Trent.

At this point, the partners began to purchase equipment, and in the spring of 1985, history was made when Catamount Brewing Company became the first microbrewery to incorporate in the Northeast. The irony of this should escape no one—this was almost a century to the day that lawmakers under the golden dome in Montpelier had outlawed the production of alcohol.

The building in White River Junction that was chosen had previously been a meatpacking plant. The three-floor building was built in 1884 and had room for expansion, so a lease was signed. Steve had it in his mind exactly how he was going to build his brewery. The problem was that there was no such thing as a small-scale brewhouse being manufactured. So he had to find equipment that could be adapted. Bank loans were secured, economic development money was found and a private stock offering raised money from friends, family and others who shared his dream. All told, $750,000 was raised with a private stock offering to thirty-two friends and relatives, a small business loan and help from the local economic development group. After Davis put his house up for collateral, they were on their way.

The chore of building a brewery now fell to Steve. While he was on a visit to Detroit to see family, he came across a twenty-eight-barrel yeast tank that had previously seen life at the Stroh Brewery. Seeing what others might not, he thought that it would be perfect as a kettle. Next, he found a vessel that he could use as a mash tun that had come from a coffee maker. New equipment would be manufactured by JV Northwest of Oregon: one thirty-six-barrel and two eighty-two-barrel fermenters and five seventy-two-barrel conditioning tanks would be built to Steve's specifications. The bottling line would come from soda manufacturer Coca-Cola, where it was first put in service in 1955, and the final key piece of equipment was a diatomaceous earth filter. Mason and his partners expected to be able to ship six thousand barrels of beer out of their new brewery.

In 1987, the first beers from the brewery were shipped in bottles to stores in Vermont. The media had created quite the buzz, and curious about their new brewery, Vermonters soon developed a taste for Catamount

Catamount hits the shelves to the enjoyment of Vermonters. *Collection of Toby Garland, photo by Kurt Staudter.*

Amber and Catamount Gold. Until these beers arrived on shelves, Vermonters had to buy imports or beers from small breweries like Anchor in San Francisco to really appreciate the brewer's art. Now not only were they tasting quality ingredients, but also the beer was fresh. In its first year, Catamount Brewery shipped three thousand barrels, or more than forty-one thousand cases, of quality beer to an unsuspecting public. The response was overwhelming.

VERMONT PUB & BREWERY

November 1988

Greg and Nancy Noonan had initially looked at building their brewpub in Greg's native Massachusetts, but when he found out that the sister-and-brother team of Janet and Peter Egelston had picked Northampton for a brewpub, the Noonans turned their attention to Burlington, Vermont. Little did they realize that it would take three years of lobbying the Vermont legislature to change the state's laws about brewpubs. As it was, one of the laws on the books since the days of Prohibition forbid the purchase and consumption of beer where it was made. This made the whole idea of a brewpub illegal, and laws like this were common all over the country.

With the help of state representative Bill Mares of Burlington and multiple appearances of Nancy and Greg before committees in Montpelier, changes to the liquor laws were guided through the legislature, and on May 18, 1988, Governor Madeline Kunin signed the law that set the stage for Vermont's emergence as one of the epicenters for the craft brewing movement. Even though there are still many archaic laws that remain on the books and the enforcement wing of the state Department of Liquor Control has a tendency of being more than a little heavy handed, Vermont was one of the first states to create fertile ground for small breweries.

The law would go into effect on July 1, but Greg and Nancy were hard at work setting up their brewpub before then. Now remember, there really was no how-to book on building brewpubs. Here in New England, there was only Commonwealth Brewing Company and the Northampton Brewery that were making it up as they went along, and then there were the Noonans. Originally, Greg had lined up some Wall Street investors for the

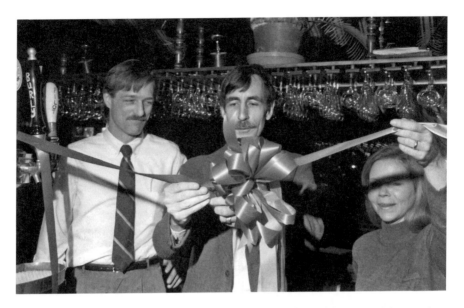

Greg Noonan (left), Representative Bill Mares (center) and Nancy Noonan (right) opened the pub on November 11, 1988. *Courtesy of Vermont Pub & Brewery.*

brewpub, but that fell through with a dip in the market. Having lost his job at a manufacturing company, Greg took his severance pay and every dime they had, raised money through family and friends and found the location where the Vermont Pub & Brewery stands today. All told, they had a budget of $175,000.

Just as Steve Mason had found out, small-scale brewing equipment was not being made yet, but undaunted, Greg cobbled together a brewing system that is a picture of Yankee ingenuity: a maple sap boiler as a brew kettle, feeding equipment for cattle and a tank that saw life previously in an ice cream factory. In the end, a fourteen-barrel brewing system with fermenters and serving tanks were shoehorned into the basement.

They worked at a fever pitch getting ready for their opening, and while the Noonans wanted everything to be perfect, they were running out of money. With enough money left for one more week of payroll, they decided that it was either do or die. On November 11, 1988, Greg and Nancy opened the doors and served their first beer: Pilot Ale.

MOUNTAIN BREWERS

November 1989

In the 1980s, Andy Pherson was spending time on the West Coast and had the opportunity to see firsthand the emergence of microbreweries. Yet another homebrewer with dreams of owning a brewery, Andy decided that he would bring the idea east to Vermont. With his partner, Jim Negromir, Andy used his business background to raise more than a half million dollars to build a brewery. The project became one of the better-capitalized breweries in Vermont to date, and in looking for a location, the partners chose Bridgewater. In town, there was an old mill along the river that had been repurposed as a retail space and business incubator. The brewery would occupy 3,600 square feet, producing beer only in kegs with a projected capacity of 3,600 barrels. The first of the beer would go out in late 1989.

Before they even brewed beer Andy had done an analysis of area bars and knew which ones were potential customers. Any bar that was pouring imported draft beer was a likely sale in his mind. Building on the groundbreaking work done by Catamount in presenting a Vermont-made beer, Andy was a relentless salesman. Long Trail Pale Ale, later just called Long Trail Ale, became their flagship beer. What is wonderful about Long Trail Ale is that it is based on the German altbier style.

Long Trail Ale quickly became an iconic Vermont brand. *Collection of Toby Garland, photo by Kurt Staudter.*

Early in the craft brewing movement, and to this day, many of the beers are based on British styles like India pale ales, bitters, stouts and porters. The reason for this is that many of the folks that came up through the homebrewing ranks were buying kits made in England, and when they started their own breweries, they stuck with what they knew. Another reason many of the new brewers continued making ales is because lagers take longer and are more challenging to make. Breweries built on a shoestring didn't have the tank space for the extra weeks it took for a lager to fully mature.

Quickly becoming a favorite with locals and a fixture at the ski areas, Long Trail Ale grew in esteem, and it wasn't be long before the two-man brewery outgrew its humble beginnings. Within its first year, Mountain Brewers was brewing seven days a week and had pushed the capacity of the brewery up to 5,600 barrels.

OTTER CREEK BREWING

March 1991

While attending school at Reed College in Portland, Oregon, Lawrence Miller was at ground zero for the explosion of small breweries in that state. As a student, he couldn't get enough of the beers from the pioneering brothers at Widmer Brewing Company, but he didn't have the money to enjoy them regularly. For Lawrence, the only way he was going to get to imbibe these kinds of beers was if he made them himself, and so another homebrewer was born. So it is not surprising that Lawrence would start to brew the same kind of beer that he enjoyed at Widmer's—a copper-colored German-style altbier. Not satisfied with what he was learning as a homebrewer, he traveled to Germany to learn more. After returning from Germany and participating in the Birthing of Giants Entrepreneurial Leadership program at MIT, Lawrence set out to find the perfect water to brew his beer.

After purchasing the equipment that made the beer he loved while he was in college from Widmer, he set up his brewery in Middlebury. Since water is the main ingredient in beer, good beer has to have good water. Lawrence found that the water in Middlebury had the perfect pH for his secret strain of German-style ale yeast. His one-man operation was based in a 10-barrel brewhouse with a capacity of 750 barrels per year and was set up in part of an industrial building on Exchange Street. Around Thanksgiving

Year-round and seasonal beers kept us coming back for more! *Collection of Toby Garland, photo by Kurt Staudter.*

1990, Lawrence started brewing test batches of beer, and with a televised tapping of the first keg at the Vermont Pub & Brewery in December, the fourth brewery in the state became official. The forty kegs of the unfiltered German altbier Copper Ale left the brewery on March 12, 1991.

McNeill's Brewery

May 1991

Ray McNeill was the first to break the homebrewer mold of the previous brewers who established breweries in Vermont. Ray and his wife, Holiday, had owned a bar in Brattleboro for five years called Three Dollar Deweys, and one of his bestselling beers was Catamount. Ray was a reluctant bar

Ray McNeill relaxes during the mash with a cold one. *Courtesy of Ray McNeill.*

owner while trying to earn the money to finish his graduate school studies in music. The bar was just the way they paid the bills. Soon, running the business had become a full-time job, and thoughts of the cello were replaced with a curiosity about making beer. Being one of the biggest accounts in southern Vermont for Catamount got Ray an apprenticeship at the brewery.

Apprenticing at a brewery is kind of like agreeing to work like a slave in all the absolutely worst jobs in the business. If you don't wash out in the first few weeks, you get to maybe help the brewer mash in or assist the cellar man in transfers, between your other responsibilities of cleaning spent grains out from the mash tun or sanitizing kegs. Ray McNeill took his apprenticeship seriously and soaked up all he could. While you do work hard, there is usually beer to be had almost all the time.

Gaining the skills he needed in White River Junction, Ray was planning a brewery to be added to Three Dollar Deweys after it was relocated to its current Elliot Street location. Originally, the McNeills bought a one-barrel

homebrew system and set it up in the basement, but it was replaced with a four-barrel system within a month.

The first beers brewed at Three Dollar Deweys were served by June 1991, and in 1992, the bar became known as McNeill's Brewery. Ray became almost a fanatic for creating beers that were true to a given style. He would pick a style that he enjoyed, and research everything he could on the beer before trying to brew it. This attention to detail quickly earned him a wonderful reputation with the growing number of craft beer enthusiasts.

LATCHIS GRILLE & WINDHAM BREWERY

July 1991

Spero Latchis of Brattleboro's landmark Latchis Hotel didn't know anything about how to brew beer, but he knew he wanted to have a brewpub in the downstairs bar and restaurant that he had on Flat Street. Not only was he a visionary when it came to the idea of locally handcrafted beer, but he also knew enough to hire the very best to consult him on building and running the brewery.

At the time, there were only a handful of companies that would help a start-up with most of them run by enthusiastic homebrewers. Greg Noonan had his hands full with his own Burlington brewery, but it is a testament to the kind of person that he was that he'd drive from one end of the state to the other, handpick someone that could run the brewery, wedge a brewhouse into the basement of an existing business and help start the operation off with some recipes.

The brewer who Greg encouraged to take over the brewing duties at the Windham Brewery was John Korpita, who was an accomplished homebrewer from the Valley Fermenters Homebrew Club down in Greenfield, Massachusetts. John quickly started getting creative with his offerings, and Brattleboro became the first town in the state with two breweries. Within walking distance of Three Dollar Deweys, soon to be McNeill's Brewery, and associated with the Latchis Hotel, the Windham Brewery planted the seed for the beer tourism boon that would overtake Vermont in the next decade.

8

1989–1993

VERMONT BREWS A NAME FOR ITSELF

With the addition of the two breweries in Brattleboro, Vermont went into the record books as the state with most breweries per capita. This is a title that has been held to this date, and no one is remotely close to providing more local watering holes that craft their own unique beers.

From the beginning, it was a challenge to get people to put down the beer brands that they had been loyal to since becoming drinkers. To this day, there are folks stubbornly clinging to mass-produced beers with little to no flavor. Many do it because it was what their fathers drank; many because it was what dads didn't drink. The early efforts by the brewers to sway popular opinion about craft beer came at tastings held at the breweries. These sparsely attended events brought together beers brewed locally along with beers being made in other countries.

One such tasting was held at the Vermont Pub & Brewery on April 3, 1989, with sixty people in attendance. Brought together for the tasting were beers from England, Scotland, Germany, Belgium and Vermont. Catamount Brewery brought its Golden Ale, and Greg Noonan presented Vermont Pub & Brewery's Bitter Winter Ale.

In 1989, Catamount Brewery was the first Vermont brewery to win a medal at the Great American Beer Festival with its Catamount Gold. By 1990, Mountain Brewers had hit a capacity of 5,600 barrels, with Pherson and Negromir brewing seven times per week. Long Trail Pale Ale won a silver medal in the 1990 Great American Beer festival. Greg Noonan continued to publish articles for professionals and homebrewers, further cementing

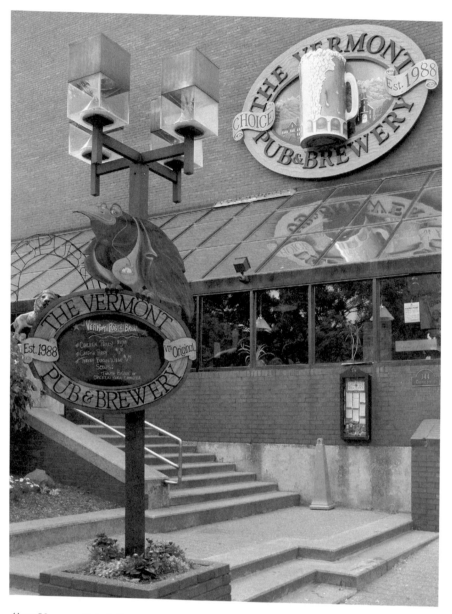

Above: Vermont Pub & Brewery is where the craft brewing scene began for most Vermonters. *Courtesy of Vermont Pub & Brewery.*

Opposite: One-off beers for special occasions can be arranged. *Collection of Toby Garland, photo by Kurt Staudter.*

his position in the brewing community. In 1991, Vermont brewers celebrated two hundred years of statehood—or lamented the 200th anniversary of the end of the Republic of Vermont, as some saw it—by brewing special beers. Mountain Brewers released Bicentennial Ale, and Catamount Brewery presented Ethan Allen Ale.

In 1988 and 1989, University of Vermont Extension professor Dr. Leonard Perry started some hops trials in Vermont, and in 1990, he presented his first findings. As you've read elsewhere in this book, hops were a huge crop in Vermont in the late 1800s and early 1900s. These early efforts by Dr. Perry continue to this day at the UVM Extension. The local brewers acted as advisors by brewing with the bounty that comes from these experimental hops yards.

In 1990, Vermont Pub & Brewery head brewer Glenn Walter brewed Black Watch to memorialize his feelings after his failed marriage and divorce. This is considered the first black IPA.

At another educational event held at the Vermont Pub & Brewery on January 27, 1992, seventy people turn out to "Meet the Vermont Brewers." The tasting presented an unprecedented nineteen Vermont-made beers. Among the beers that were presented were Horne's 80-Shilling Export Ale and Februaryfest by the hosts, Frankenspice Ale and Moonbeam Ale from the Windham Brewery, Catamount's Amber and Christmas Ale, Mountain Brewers's Long Trail Ale and Otter Creek's Stovepipe Porter and Copper Ale.

With the increased enthusiasm for better beers, more homebrew shops opened up. The Brew Lab in St. Albans, Something's Brewing owned by

Tom Ayres and Vermont Homebrewers Supply in Burlington started selling kits and ingredients to brewers. It is these shops, and the homebrew clubs that came next, that acted as the farm teams for the growing number of professional brewers in the state.

Half of the New England medals at the 1991 Great American Beer Festival were won by Vermont brewers. Long Trail Ale won gold, and Mountain Brewers also won silver with its Northern Light. Vermont Pub & Brewery brought home a bronze for its Vermont Smoked Porter. In 1992, Mountain Brewers won a bronze for its Centennial Ale, and Vermont Pub & Brewery hit bronze for the second year in a row with the Vermont Smoked Porter.

This was a time of growth for these new breweries. Catamount expanded in 1991, adding tanks and employees; Mountain Brewers tripled capacity by adding a bottling line and taking over ten thousand square feet at the Bridgewater Mill. The brewery also added five employees to the payroll. Catamount contract brewed Le Garde French Country Style Beer for the short-lived Dark Cloud Brewery based in White River Junction.

In the fall of 1992, the first brewer's festival was held at Sugarbush in Warren. Forty different beers were served at the event organized by Jay Canning.

JASPER MURDOCK'S ALEHOUSE

May 1993

Tim Wilson was a banker before he was an innkeeper/brewer. His employer gave him the task of overseeing a number of properties that the bank had taken back because of defaults and finding people to run the inns until the bank could find a buyer. One of these properties was the Norwich Inn, and after it failed, Tim knew just the person to run it for him. While working for the bank, he'd met a woman that was looking to purchase an inn, and he decided to approach her with a job offer. Working together on the foreclosed property, they developed a relationship that grew beyond their professional lives. They eventually got married and purchased the inn.

In the history of Vermont, there were perhaps only a few others who threw themselves into the role of innkeepers the way that Tim and Sally did. They worked hard to restore the inn to its previous glory and became almost obsessed with the history of the property. The property had been built in

1797 by a fellow named Jasper Murdock, and it is Tim's belief that when he started brewing at the inn, it was in keeping with a long-standing tradition.

Becoming only the second hotel in the state to brew its own beer, Jasper Murdock's Alehouse quickly became a destination to enjoy good beer, and it didn't hurt that the Catamount Brewery was in the next town and the Mountain Brewers just down the road a piece. Vermont's Windsor County for a while had more breweries than anywhere else in the state.

The brewery that Tim built was little more than a homebrew setup. Glass carboys bubbling away in the corners were a common sight. In many ways, Jasper Murdock's was the state's first nanobrewery, and it promoted itself as the smallest commercial brewery for many years. The English-style ales were brewed on a half-barrel Pico Brewing System manufactured in Ypsilanti, Michigan, but in less than a year, it expanded to a four-barrel brewhouse in the old livery building. Even with the new brewhouse, Jasper's only brewed around two hundred barrels per year. With the same enthusiasm that he brought to innkeeping, Tim threw himself into his role as gentleman brewer. To see Tim behind the bar serving up the brewery's flagship Whistle Pig Red Ale, you couldn't help but believe that the spirit of old Jasper Murdock was alive and well in Norwich, Vermont.

MAGIC HAT BREWING COMPANY

November 1994

Alan Newman and Bob Johnson were both thinking about starting a new business. A chance meeting of these friends got them to believe a brewery was what was needed in Burlington, and Magic Hat was born. Alan had been involved in a number of businesses from the beginning and had a flair for the flamboyant. Bob had been an avid homebrewer who had taken the next step in the process by working as an assistant at Otter Creek Brewing.

Together they would come up with some recipes that were just a little outside the box for the commonly defined styles, and with Alan's over-the-top and outrageous marketing schemes, one of the most unique breweries to emerge on the craft beer scene was born. Another first for the duo was that they became the first Vermont brewery to contract its initial offerings until it raised enough money to build its own brewing facility. While Catamount Brewery had been using its extra capacity to brew for other out-of-state

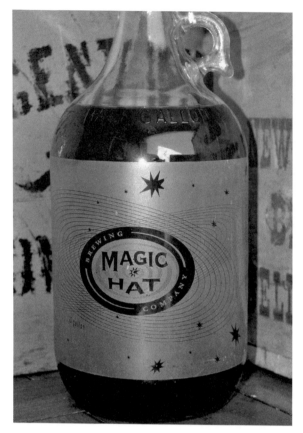

With Magic Hat, it's always "a performance in every bottle." *Photo by Kurt Staudter.*

breweries, Magic Hat Brewing was the first big Vermont start-up to use the model pioneered by Jim Koch of Samuel Adams of not owning a brewery at first and had its beer contract brewed elsewhere.

Within a year and a half after going into business, Alan and Bob were ready to build a brewery, and they found a location on Flynn Avenue. The brewhouse they chose was a system designed by consultant Peter Austin & Partners of Maine. The only part of the fifteen-barrel brewhouse that wasn't from Peter Austin was the hot liquor tank, which was a converted milk truck tank. Until Magic Hat was up and running, its beers were being brewed in Maine, drafted at Kennebunkport Brewing and bottled at Shipyard Brewing Company.

With a very ambitious production schedule of brewing two times per day five or six days a week, Magic Hat projected that its new brewery would produce between nine and ten thousand barrels per year. With the opening of the new brewery, all production of Magic Hat's beer in kegs was moved from Maine to Burlington. Within a few months, another thirty-barrel fermenter was added, and the brewery signed a distribution deal with Dewitt in Brattleboro. Magic Hat would also be available in Maryland.

Always the promoter and showman, Alan helped get the public whipped into a frenzy for an open house, which the brewery held on January 22, 1995. Between four and five hundred people turned out to try Heart of

Darkness Stout. This was perhaps the biggest single event held by a Vermont brewery up to that time.

SHED RESTAURANT & BREWERY

December 1994

This is just like the classic story of the phoenix rising up from the ashes. On January 26, 1994, the Stowe landmark Shed Restaurant burned to the ground after twenty-nine years of providing burgers and beer to both locals and visitors. The next day, employees, who now believed they were out of work, were called by owners Ken and Kathleen Strong and told that the popular location would be rebuilt. Not only would it be rebuilt, but it would

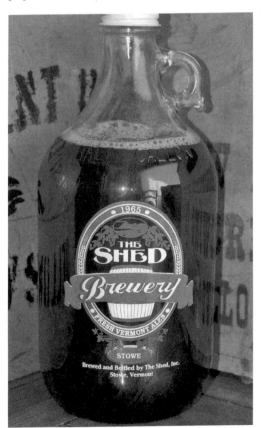

also be a replica of the original with one exception—it would include a brewery.

For the second time in Vermont, an owner of a business had the vision to see that the craft brewing movement wasn't a fad and that Vermont was at the center of the action. The investment by Ken Strong in the Peter Austin's brewhouse, and with the hiring of professional brewer Chris Ericson formally from Shipyard Brewing Company and Federal Jacks in Maine, the Shed was quickly on the road to being known for being more than just a great place to

Shed growlers got distributed regionally. *Photo by Kurt Staudter.*

come after a day of skiing. The first of the recipes brewed by Chris were modeled after the start-up brews that were part of a Peter Austin/Alan Pugsley contract, but it wouldn't take long for him to spread his wings.

Among the innovations that came from the Shed included the commitment to selling growlers for off-premise consumption, distribution of the growlers into stores and the wonderful "Ski of Beers" sampler with five different beers set up on a short ski. It wasn't long before Chris came out with one of the iconic beers in Vermont: the Shed's Mountain Ale.

BLACK RIVER BREWING COMPANY

March 1995

Having grown up in St. Louis, Tom Coleman was no stranger to beer, but when he moved to Berkeley, California, to go to college, he had a beer epiphany when he first tasted the growing number of microbrews. It was then that he started brewing his own beer. After graduation and spending some time as a professional stagehand touring the country, Tom sought out as many craft breweries as he could along the way. Road weary and sitting at the bar of the Breckenridge Brewing Company in Colorado, Tom looked out at the mountain and then at all the happy people working at the brewery and decided that this was what he wanted to do with his life.

Tom returned to the West Coast and started doing the due diligence of researching locations and writing a business plan. Next, he knew that he would need some professional brewing experience, and so he attended the Siebel Institute. His education continued while he got practical experience at Anchor Brewing and returned to St. Louis for some time at Schafly Brewing.

Picking Ludlow because of Okemo Mountain Resort, Tom came to Vermont and spent the next two years looking for a location. He took on some partners and brought on longtime friend John O'Brien to run the food part of the business. The Main Street location wasn't exactly what he wanted, but Tom quickly turned the narrow bar with a black-and-white tiled floor into something special. The walls had stuff from local artists, and the food was great. It was a fantastic place to hang out.

The pub was open before he had all the permits to make beer, but when he started brewing, it was like the flood gates had been opened. Brewing three times per week, Tom expected to be able to push two hundred barrels

per year out of the system. The first beers to be served were Blind Faith Pale Ale and Oh Be Joyful Porter.

MADISON BREWING COMPANY

February 1996

A lot can happen to kids when they go off to college, and what started as a class project about the brewing industry for Mel Madison at Western New England College has become the family business. Mel's marketing professor was Paul Castanza, formerly of Miller Brewing Co., and Mel had started homebrewing at the time. During his presentation for his project, he provided his fellow students with beer that he'd made. As you might imagine, this was quite the hit.

Mel's parents owned the oldest dairy bar in the state in Bennington, so the idea of opening a restaurant wasn't a hard sell to the family. Mel's brother Mark had also started homebrewing, and it was decided that they would explore the idea of having the restaurant be the first brewpub in Bennington. This was an idea that was reinforced in Mel's mind when he read an article in *Entrepreneur* magazine. The family started working up their business plan, building on what was started in Mel's business class, and they decided to hire a consultant to help them start the brewery.

Madison Brewing growlers are perfect for a summer picnic. *Photo by Kurt Staudter.*

By the summer of 1995, a number of breweries in Vermont had already made use of the services of Alan Pugsley installing Peter Austin systems, and Mel's father, Mike, went to the Shipyard Brewery to check out the apprenticeship program. After the weekend program, he signed up Mel and his two brothers, Mike and Mark, for the two-week apprenticeship. Over the course of the program, they learned the nuts and bolts of the brewing business.

Returning to Bennington, they set to work installing their brewery and setting up the restaurant. There were some design flaws in the way the place was set up. The brewery was smack dab in the middle of everything. Now, while this is great for people who want to watch the brewing process, it does generate quite the amount of humidity. Also, unlike other brewpubs, you don't normally see sacks of grain stacked all over the restaurant dining room.

Maybe it was the enthusiasm of youth or that these guys were just very motivated, but even to this day, there are very few folks that work as hard as the Madison brothers. While most owners would sit at the bar and be a publican, the brothers more often than not are working the floor waiting tables.

JIGGER HILL BREWERY/TUNBRIDGE QUALITY ALES

April 1996

Another homebrewer who went pro, Liz Trott, started out making beer for her friends, but they went through it too fast. She soon realized that you'd work for hours on a brew and wait weeks for it to finish, and then you and your friends would polish it off in an afternoon. Brewing on the scale of a homebrewer just wasn't worth the effort. Also like many of those who came before her, Liz and her partner, Janice Moran, along with assistant brewer Jim Fullerton, all kept their day jobs at first.

The original brewery was located in Tunbridge off the Dickerman Hill Road. People today are amazed at what one has to go through to get to the Hill Farmstead Brewery, but even Shaun Hill had nothing on the folks at the Jigger Hill Brewery. Two miles off Route 110, getting to the brewery during mud season was an adventure.

The four-barrel system was located in the welding shop of a barn and designed by Pierre Rajotte of Montreal. Liz and her partners started

These Tunbridge Quality Ales labels are from before the move to South Royalton. *Collection of Toby Garland, photo by Kurt Staudter.*

churning out the brand Tunbridge Quality Ales at a rate of forty barrels per month. The beers were unfiltered and quickly gained a loyal following. In order to use up some excess capacity, they were also quick to identify some local accounts to do contract brewing. Beers would be made for Norwich's landmark general store Dan and Whit's and Crossroads Restaurant in South Royalton.

Although many of their beers, such as Telemark Mild, Covered Bridge IPA and Ox Pull Stout, were instantly popular, the seasonals Vermont Sap Brew and the World's Fair Special were the most sought after. The Vermont Sap Brew was a delicious amber beer made with maple sap and perfectly balanced with hop bitterness. The beer made each year for the Tunbridge World's Fair started out as a Belgian, but it eventually became the beer that won a homebrew contest run by the brewery each year.

Distributing its beer in kegs and twenty-two-ounce bottles, Jigger Hill Brewery soon outgrew the barn. Perhaps the most significant thing about the brewery was that it was owned and operated by women. This was a first in Vermont, and to this day, it is very rare in the industry. Liz Trott was a Vermont brewing pioneer in every sense of the word.

BENNINGTON BREWERS

January 1996

This was a short-lived company that was started by homebrewer Frank Murray in Bennington. According to material presented by the company, the beer was distributed in three states and won a number of awards. They operated out of a storefront with samples and growlers. By 1997, Frank was focusing more time on his day job in international banking.

RUBEN JAMES RESTAURANT & BREWERY

June 1996

At this point in Vermont, being a microbrewery was a big draw. So when James Sherman, president and owner of One World Brewing in Williston, came to restaurant and bar owners with a turnkey system and the promise of helping them through the state and federal regulatory hurdles of opening a brewery, many thought that adding "& Brewery" to their name would help set them apart in the very competitive restaurant and bar business.

Ruben James Restaurant in Burlington became the first Vermont customer of One World Brewing. After a brief training period, the company sold the new brewery extracts to make beers. While the business could now say it was a brewery, many of the folks that were driving the craft beer movement dismissed such establishments. What was worse is that these "extract breweries" were universally despised by the professional brewing community.

ONE WORLD BREWING

1996

In many ways this was a good idea that was poorly executed. Giving a business the ability to say it was a brewery would help lots of bars and restaurants set themselves apart. James Sherman would purchase your equipment, set it up, get you through all the paperwork and regulatory reporting, teach you

how to brew and sell you all the ingredients that you'd need—what could be easier?

Then he brought on Dean Bloch, an award-winning homebrewer as a trainer, and Glenn Walter, formerly the head brewer of Vermont Pub & Brewery and now running Three Needs, as the head of operations. The customers would get to train at Three Needs Brewery & Taproom for two weeks, and then One World would help come up with recipes. It is important to note that while Three Needs was a real brewery, the One World systems were made out of plastic fermenters and employed a single wall electric brew kettle, making it little more than a homebrew system.

Three Needs Brewery & Taproom

October 1996

You could say the beer business was in Glenn Walter's blood. His grandfather was a tavern owner who set his grandson at the end of the bar and fed him pretzels and cokes. He spent the day interacting with patrons and hustling shuffleboard.

After working his way up to head brewer at the Vermont Pub & Brewery and brewing for six years with Greg Noonan, Glenn decided that he would follow in the family business and open a pub in Burlington that would channel the spirit of his grandfather's place. He wanted to have a bar that the locals would enjoy. He wasn't looking to open a brewpub; he wanted to own a bar, and given his experience as a brewer, there was always an expectation that he would brew beer at the Three Needs Brewery & Taproom.

It would seem that Glenn has achieved his goal. The place has a pool table, and one of the place's wonderful and unique quirks is the patrons' devotion to the television program *The Simpsons*. The taproom's daily "Duff Hour" has generously reduced pint prices on a single featured keg. Catering to a younger crowd at night than most other craft beer establishments, Three Needs still is a great place for others to stop in after work for a pint.

After Glenn cemented his reputation as Burlington's beer bar, patrons only had to wait a year before he was brewing again. The system that he assembled included a kettle and mash tun by Yvon Labonne of Stainless Steel Specialists, Grundy tanks converted by Gary Brown into conical fermenters

and conditioning/serving tanks crafted in Vermont by Victor Giroux. With thirteen conditioning tanks, Glenn promised that the extra capacity would be devoted to lagering. Each batch of beer was to be 3.5 barrels, and along with brewer Dan Lipke, Glenn ended up brewing once or twice a week.

Considering that the taproom had quality, hard-to-find guest taps, Glenn wanted to brew styles that were not generally available. The beers that

What are the three needs? One is surely beer. *Photo by Kurt Staudter.*

came next always had a whimsical playfulness. It was as if Three Needs was channeling the same wacky spirit that lives in the Magic Hat Brewery.

Franklin County Brewery

November 1996

When Bennett Dawson started the Brew Lab homebrew shop in downtown St. Albans, it was in the back of his mind that he'd someday own a brewery. Within three years, he was using extra space at the Brew Lab to build that brewery. With a perfected recipe, Bennett was well on his way to realize his dream. While he would initially look at building a four-barrel system, he decided instead on a seven-barrel system manufactured by Criveller in Canada, while rounding out the brewery with two fifteen-barrel fermenters and fourteen-barrel conditioning tanks.

This was a nice little brewery, and Bennett took the time to build it right. Soon, along with head brewer Stan Beauregard, he was brewing double batches of Rail City Ale and packaging it in kegs and sixty-four-ounce growlers. The beer was in many ways a wonderful amber session beer and

Steel Rail Ale from Franklin County Brewery would be distributed as far as Syracuse, New York. *Collection of Toby Garland, photo by Kurt Staudter.*

quickly became popular in area bars. The one beer–draft only business model served Bennett and Beauregard well. During the first year, they expected to ship 1,300 barrels. There were also plans from the beginning to purchase a bottler and distributing twelve-ounce bottles within the first year.

Rail City Ale was yet another example of the German alt style that entered the marketplace in Vermont. The beer was filtered and painstakingly crafted to Bennett's exacting standards. Brewed and conditioned a little longer, his beer was a top-notch beer that was well received. It wasn't long before the brewery had to start looking to expand.

GOLDEN DOME BREWING

December 1996

Here is yet another story of homebrewers gone pro, with a twist. Russ FitzPatrick and Ian Dowling were homebrewers who had worked together at the Something's Brewing homebrew shops with a desire to brew professionally. Here's the twist: Russ took his love for brewing and ventured out to the University of California–Davis to study under Michael Lewis, where he graduated in 1995 as a master brewer. After that, he worked at

Golden Dome in Montpelier would fill your growler with Ceres Back 40 Amber Ale. *Collection of Toby Garland, photo by Kurt Staudter.*

Pyramid Brewing. During his homebrewing days Russ had perfected a recipe and fine-tuned it while in California. That beer became Golden Dome's flagship: Ceres Back 40 Amber Ale.

For two years, Russ and Ian planned the brewery and settled on a location along the Winooski River in Montpelier in an industrial space that had formerly been a granite shed. The ten-barrel system they obtained was designed for Bert Grant and Yakima Brewing & Malting Company in the 1980s and was purchased from Star Brewing in Oregon.

The space they leased was 2,500 square feet with the ability to double in size as the brewery grew. The original plan was to produce 1,500 barrels per year with a long-term goal of 10,000 barrels.

TROUT RIVER BREWING COMPANY

December 1996

As a homebrewer, Dan Gates won a gold medal for his scotch ale in the prestigious American Homebrewers Association's yearly contest. With the encouragement of friends, he and his wife, Laura, decided that they wanted to open a brewery in the Northeast Kingdom. They wrote a business plan and took two years to secure financing and find a location. At first, they thought that they'd build the brewery in Jay, but because

Trout River always had a huge selection at the pub to bring home in a growler. *Photo by Kurt Staudter.*

of the wastewater situation and reluctance on the part of the Selectboard, they went to East Burke instead. Even though they painstakingly researched their new start-up, they still grossly underestimated the overwhelming demand they ended up seeing for their beers.

Dan and Laura opened the brewery with a four-barrel brewhouse and made Dan's award-winning Scottish ale. They also became very popular with their Rainbow Red Ale and Hoppin' Mad Trout Ale. In the downtown leased space, they had retail sales in addition to self-distribution. The routine was to be open and brewing every day, except Tuesday, when they went out to deliver and sell beer.

During that first year, they were able to ship five hundred barrels.

They were halfway into their second year when they realized that they had already shipped more beer than they had made in the whole first year. At that point, they decided to go with a distributor. Demand was still outstripping supply, so they added some larger tanks and started brewing double batches. In the second year, they shipped 1,200 barrels, working sixteen-hour days on a regular basis. This all but maxed out what they could do at their first location.

9
1993–1996

VERMONTERS LOVE THEIR LOCAL BREW

Before 1996 there were ten breweries in Vermont; then, in 1996 alone, eight new breweries opened. Perhaps it is unfair to count Ruben James among those eight, but according to the federal and state liquor regulators the company was still a brewery.

Otter Creek Brewing couldn't make beer fast enough in 1993, seeing the production skyrocket with the addition of a bottling line. The brewery doubled its output to eight thousand barrels per year, added four forty-barrel fermenters and began offering new beers in addition to the Copper Ale.

In 1993, Alan Davis, the cofounder of Catamount Brewery, left the company. Later, he explained that he left out of frustration that more wasn't being done to market the brand. He took the position of Vermont commissioner of economic development.

In the fall of 1993, the Vermont Brewers Festival was held on the Burlington waterfront. Promoter Jay Canning boasted 125 different beers to sample.

By early 1994, Peter Austin and Alan Pugsley had begun their consulting group and became the "Johnny Appleseeds [?] of Craft Breweries" with their distinctive strain of Ringwood yeast.

In 1994, Green Mountain Beverage Holding Company and Vermont Brewery was formed by a European brewer to explore entry into the red-hot Vermont craft brewery scene. Other than some initial attention in the media, this quickly faded away. This was one of the early examples of being "crafty" instead of being a craft brewery. By the 1990s, beers sales as a whole were stagnant; however, craft beer sales were on a slow but steady rise. This got the

Images of poster-sized beer labels. Check out Golden Dome's label in particular. *Photo by Adam Krakowski.*

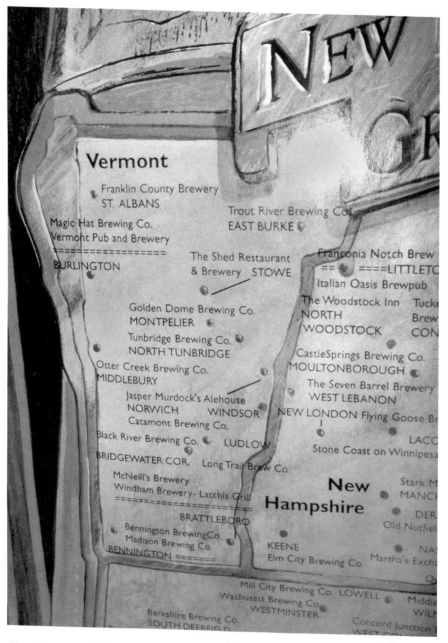

Above: Beer map of Vermont—sixteen breweries are listed, and most are still around. *Photo by Adam Krakowski.*

Opposite: Tunbridge poster label. *Photo by Adam Krakowski.*

attention of the large breweries both here and in other countries. Those breweries began to buy into some of the more successful craft breweries or began to market their own "craft" brands.

Greg and Nancy Noonan opened their second brewpub in early 1994 in West Lebanon, New Hampshire. The Seven Barrel Brewery was built to Greg's exacting specification and included a homebrew supply store. The artwork promoting the beers would all be Greg's, and lessons learned in Burlington made this opening that much easier.

McNeill's Brewery added three fifteen-barrel unitanks and one seven-barrel unitank designed by Ray, along with upgrading the brewhouse to seven and a half barrels. Unitanks are a combination fermenter and conditioning tank. McNeill's also won a bronze medal at the Great American Beer Festival in the Blonde Ale category in 1994; and in 1995, the brewery won gold for its Dusseldorfer Altbier and an honorable mention for the Pullman Porter. Twenty-two-ounce bottles began to be distributed to area stores in 1994.

Vermont Pub & Brewery brewed the first Rauchbier in New England. Greg Noonan used a combination of apple, hickory and maple woods to smoke the grains. He found that by damping the malts, he got better results. The Vermont Smoked Porter became a big hit at the pub.

Mountain Brewers began the first of its Brown Bag Series with low-cost packaging to present experimental beers. The brewery expanded to 14,999 barrels in order to stay under the 15,000 limit to be considered a craft brewery.

The Windham Brewery lost its original brewer John Korpita when he left in 1995 to brew for a little while at the Berkshire Brewing Company before working with Greg Noonan to start the Amherst Brewing Company.

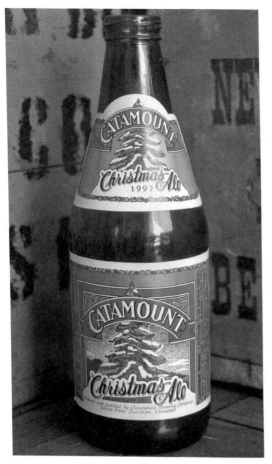

A few years later, Catamount's Christmas Ale became the White House beer for Bill and Hillary. *Collection of Toby Garland, photo by Kurt Staudter.*

The first test batch of Berkshire's Steel Rail Pale Ale was brewed in Vermont at the Windham Brewery with Chris Lalli and Gary Bogoff to woo investors. John handed over the reins to Dan Young.

In May 1995, the Vermont Brewers Association formed and held its first meeting at the Latchis Grille at the Windham Brewery. The association was created in order to promote Vermont beer through marketing and festivals, watch the Vermont legislature and foster an air of camaraderie and mutual cooperation among the brewers. Lawrence Miller of Otter Creek was the first president, and Chris Ericson of the Shed is the first secretary.

Dr. Leonard Perry of UVM reported that during the last four hops harvests, researchers had been able to pinpoint which hops grew best in Vermont. German and East European varieties seemed to do poorly, while Chinook, Aquila, Nuggett and Fuggles seemed to do quite well.

Magic Hat introduced #9 Not Quite Pale Ale in 1995 and sales took off. The brewery added two new 30-barrel fermenters, and its output was up to 120 barrels per week by the end of the first year. While looking to expand, the brewery was delayed when its first location became embroiled in a controversy between the city and the local bus line.

Catamount Brewery was chosen for its Christmas Ale to be the holiday beer at the White House by Bill and Hillary Clinton in 1995. Catamount

was experiencing unprecedented growth at more than 20 percent, becoming the first New England brewery to outgrow the microbrewery category. The brewery began to look for a location to expand its operations to fifty thousand barrels per year.

By June 1996, market research conducted by Andy Pherson had concluded that, in Vermont, the specialty beer category occupied 40 percent of beer sales. He noted that the Vermont beer drinker was fiercely loyal to his or her local brands and that the only other place in the country that was seeing this kind of market penetration in craft beer sales was the Pacific Northwest.

Otter Creek, Long Trail and Catamount Expand

During 1995 and 1996, Otter Creek Brewing and Mountain Brewers both made huge investments in their breweries by building facilities from scratch. Catamount Brewery wasn't far behind in 1997. These expansions marked a milestone in the history of brewing in Vermont. Before then, Lawrence Miller, Andy Pherson and Steve Mason were having trouble answering the demand for their beer from Vermonters, let alone being able to accommodate the phone calls that were coming from out-of-state distributors. From this point forward, Vermont beer would be shipped far and wide.

First to start construction was Otter Creek in 1995 just down Exchange Street from where it all began. Brewers worked at a fevered pace in order to make the transition from one facility to the other without too much of a lapse in shipments to the distributors. The new facility drew over five hundred for the grand opening on October 8, 1995.

The brewery now boasted fifteen thousand square feet with a custom-designed brewhouse, considerably more tank space and a visitors' center for tastings. Designed and constructed by Century Manufacturing from Ohio to the exacting specifications of Lawrence Miller, the brewery was, for a time, the most sophisticated brewing facility in America. One of the more dominant features was the two-hundred-barrel fermenters that towered over the outside of the building. Another investment was in the state-of-the-art German bottling line capable of running four times as fast as what Otter Creek had been using. With construction and moving completed in the last half of the year, production for Otter Creek ended the year at ten thousand

barrels. The expectation was that the new brewery would be able to hit forty thousand barrels in 1996. Otter Creek acquired contracts with distributors to ship beer to New Hampshire, Massachusetts, Rhode Island and parts of upstate New York.

Not to be outdone, Andy Pherson and Mountain Brewers moved into their new seventeen-thousand-square-foot brewery just down the road in Bridgewater Corners in January 1996. With the move came a name change as well: Long Trail Brewing Company, named after the flagship Long Trail Ale. The new brewery eventually boasted of a total of six sixty-barrel unitanks, better loading dock facilities, an improved grain handling system and the finest visitors' center at any of the production breweries.

The sprawling campus, which was formerly a riverside farmer's field, included the most sophisticated wastewater treatment facility at any of the Vermont breweries, and Long Trail set the standard for limiting the amount of water used in the brewing process. Outbuildings of the farm were put to use for storage, and the old farmhouse was used by the former owner as part of the deal.

The visitors' center is nestled alongside the Ottauquechee River and has a beautiful bar and comfortable space inside with Vermont charm and views of the brewery production floor, but it is the outdoor deck that is unequalled. Set up right along the river, there is perhaps no better place in Vermont to enjoy a beer.

The Catamount celebrates ten years in a new brewery. *Collection of Toby Garland, photo by Kurt Staudter.*

Top: A steam lager made by Mountain Brewing Company from Walpole, New Hampshire, circa 1890. *Collection of Toby Garland, photo by Kurt Staudter.*

Left: An example of a Massachusetts beer that was bottled in Burlington. *Collection of Toby Garland, photo by Kurt Staudter.*

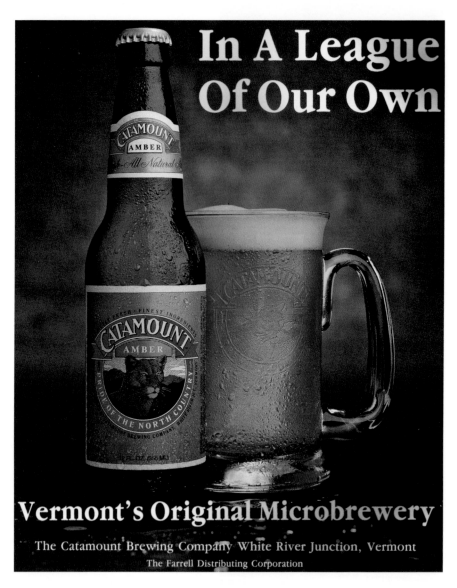

Catamount ad from 1994. *Photo by Kurt Staudter.*

Top: You can grab an Otter Creek to go. *Photo by Kurt Staudter.*

Left: Otter Creek introduces us to Hickory Switch Smoked Amber Ale. *Collection of Toby Garland, photo by Kurt Staudter.*

Top: McNeill's enters the marketplace with these beers contract brewed by Catamount. *Collection of Toby Garland, photo by Kurt Staudter.*

Left: Madison's Brewing starts bottling to deal with extra capacity. *Collection of Toby Garland, photo by Kurt Staudter.*

Left: The World's Fair hasn't been the same without Tunbridge Quality Ale's Special, and Liz Trott of Tunbridge takes a stand for gay rights. *Collection of Toby Garland, photo by Kurt Staudter.*

Below: Jasper Murdock's is not so different one hundred years later—only now there's beer! *Photo Paul Kowalski.*

The Shed is a Vermont landmark brewery, located on Stowe Mountain Road. *Courtesy of Vermont Brewers Association.*

Trout River Brewing of Lyndonville. *Courtesy of Vermont Brewers Association.*

Above: The Long Trail brewery moves into a new facility. *Courtesy of Vermont Brewers Association.*

Left: Long Trail Double Bag named by Paul Kowalski. *Photo by Adam Krakowski.*

Left: Switchback Ale.
Photo by Adam Krakowski.

Below: In the face of a
series of unfortunate
circumstances,
Stonecutters brewed on.
Photo by Kurt Staudter.

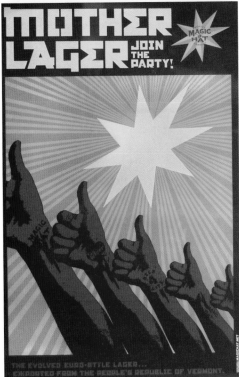

Top: The champion of the Monster war: Rock Art's Vermonster. *Photo by Adam Krakowski.*

Left: Magic Hat has flair for the flamboyant. *Photo by Kurt Staudter.*

J.P. Williams relaxes after a long day at the lager factory—we should all be so lucky! *Photo by Kurt Staudter.*

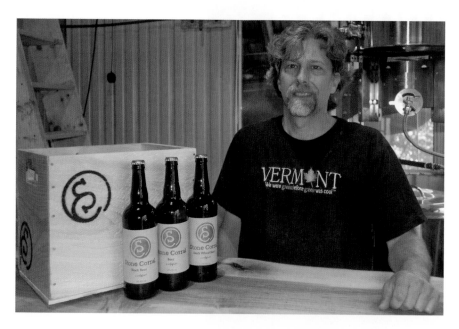

Bret Hamilton is the proud owner of the biggest brewery in Huntington—Stone Corral Brewing. *Photo by Kurt Staudter.*

Above: Murray Seaman and Glenn Cummings show off their new brewhouse at Infinity Brewing. *Photo by Kurt Staudter.*

Left: Switchback bottles, then and now. *Photo by Kurt Staudter.*

Backacre Beermakers, a bottle three years in the making. *Photo by Adam Krakowski.*

Left: The Foley brothers open the first Rutland County brewery. *Photo by Adam Krakowski.*

Below: Lawson's maple beers. *Collection of Tucker Hayward, photo by Krakowski.*

Hill Farmstead beers. *Collection of Tucker Hayward, photo by Krakowski.*

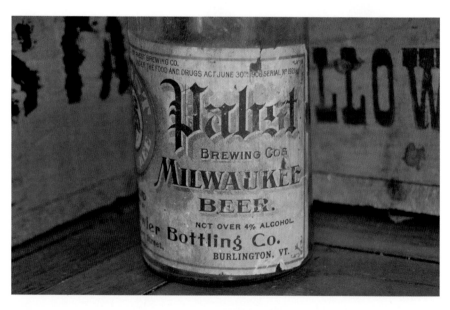

A circa 1910 Pabst Blue Ribbon Ale that was bottled in Burlington. Note the "Not Over 4%" on the label. *Collection of Toby Garland, photo by Kurt Staudter.*

A beer flight at the Trapp Family Lodge. *Courtesy of Wayne Marshall.*

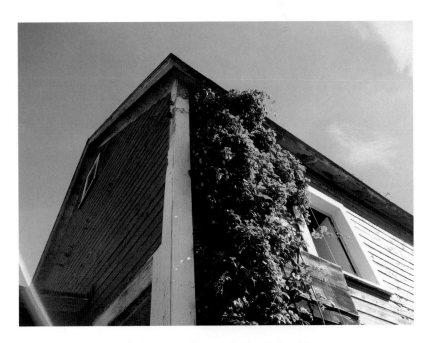

Native Vermont hops climb a barn. *Courtesy of Adam Krakowski.*

Sucker Pond Blonde

A light German bier brewed with saaz hops

(Blonde)

Buck's Honey Wheat

An American wheat beer, brewed with real Vermont Honey

(golden)

Willoughby's Scottish Ale

A traditional Scottish ale with a rich malt aroma and hop balance

(Red)

Crowtown Pale Ale

An English style pale ale brewed with Fuggles and East Kent Goldings Hops

(Golden)

Old 76 Strong Ale

A rich English Yorkshire style ale with fruity undertones and a smooth finish

(Dark Amber)

Seasonal Special

Madison's offers several unique brews throughout the year. These Special seasonal brews are only made for a short time. Ask your server about the seasonal brew available now

Above: Beer tasting at Madison Brewing Co. *Courtesy of Victoria Russo.*

Left: Rock Art Brewery's Midnight Madness Smoked Porter. *Courtesy of Cameron Butova, Flickr.*

By December 1996, Catamount had also found a new location and broke ground on what would be the largest brewery in the state at twenty-five thousand square feet. The facility, located in a Windsor industrial park, had ample room for a brewery store and tasting room, and off to one side, there was a huge space for a restaurant brewpub to be added later. Steve Mason projected that the yearly output of the new facility would be around fifty thousand barrels.

Catamount's expansion represented an unprecedented investment of over $5 million with the money being raised through a bank loans, the Vermont Economic Development Agency and the Small Business Administration. The new brewhouse had a fifty-barrel Santa Rosa stainless-steel system with a mash/lauter tun that would let the brewers brew in a traditional British way. The new facility also had six two-hundred-barrel Mueller unitanks on the outside of the building, improved filtering equipment, two two-hundred-barrel bright tanks and a state-of-the-art Krones bottling line capable of producing 150 bottles per minute.

On August 4, 1997, the new brewery was in operation, and in a made-for-the-media event, yeast was transported from the original brewery in White River Junction by a flotilla of canoes down the Connecticut River to the new brewery in Windsor. On that day, over 1,500 people turned out for the grand opening with music, food and, of course, beer. A dunkelweizen called Catamount Windsor Wheat was brewed for the occasion, and the first beer that came out of the new brewery was Catamount's Octoberfest.

Gallagher's Pub

January 1997

Steve Polcek was the owner of the popular nightspot Gallagher's Pub in Waitsfield. Although the pub was already the gathering point for the after-ski crowd and locals in the Mad River Valley, Steve was always looking for new ways to promote his business, and he was quick to offer the locally brewed beers on tap for his customers. When One World Brewing offered to set up a microbrewery in his bar, he jumped at the chance to be the second client for the young company in Vermont.

For a number of years, Gallagher's Pub made Sugarbush Ale, Mad River Stout and Maple Old Ale based on the extract recipes that were developed for them by One World Brewing. Once again, this so-called

brewery would be somewhat shunned by the growing number of craft brewers and their adoring fans.

ROCK ART BREWERY

November 1997

Matt and Renée Nadeau started their brewery at home. Matt was another homebrewer with dreams of making it big, and being the pragmatic Vermonter that he is, he started small. They raised every cent they could to sink into their brewery. Their home in Johnson was quickly overrun with brewing equipment, and the smell of mashing grains took years to go away after they moved the brewery to Morrisville.

The Johnson location for the brewery contained equipment that was a hodgepodge of dairy and maple sugaring equipment, along with new and used brewing equipment. All of this was crammed into the basement and garage. The Nadeaus signed with a distributor and dealt with the same problem that everyone before them had—they couldn't make beer fast enough. Almost immediately, they had to purchase two more fermenter/ conditioning tanks and use some good-old Yankee ingenuity in figuring out how to wedge them into the basement.

SALT ASH INN

May 1998

Glenn Stanford was a homebrewer who also had an inn. The Salt Ash Inn in Plymouth sits at the intersection of Routes 100 and 100A and had always been a popular stop for bike tours. To give his customers a little something extra he went through the regulatory hurdles to become a licensed brewery. Even though he was only brewing twelve-gallon batches, he made sure that at least four of his eight taps poured his beer.

The flagship beer was the Innkeeper's Amber, but he also brewed Salt Ash Stout with Green Mountain Roasters coffee. Beers were brewed here until 2000, when the Stanford's sold the inn.

BURLINGTON BREWING COMPANY

1998

While not a production brewery or a brewpub, the Burlington Brewing Company in Shelburne became one of a handful of businesses called a "Brew on Premise" shop. Eric Morris and Nate Schuppert helped their customers become brewers. You could come here and brew a batch of beer, design labels and return in a couple weeks to pick up a few cases of beer that you made. All the ingredients needed were in the shop, and the staff was there to answer your questions while helping you create the kind of beer you wanted. The cost of each session was based on how big a beer you wanted to make. It makes sense: the more ingredients the higher the cost.

Many folks brewed their first batch of beer at the Burlington Brewing Company and went on to become homebrewers. Others came only once to make a wedding gift or brew a beer for another special occasion.

WOLAVER'S ORGANIC

1998

Morgan and Robert Wolaver had a great business plan. The Panorama Brewing Company of Santa Cruz, California, was making 100 percent certified organic ales. The brewery's three beers under the Wolavers' brand were a pale ale, brown ale and India pale ale. While the Wolavers didn't own a brewery, they had distribution contracts all over the country and contracted out the brewing operations to brewers in select locations.

When the Wolavers approached Lawrence Miller of Otter Creek Brewing with a proposal to contract brew the hottest-selling organic brew in the country, it wasn't just another contract brew. Instead, by brewing the beer, Otter Creek would become a partner and an equity owner of the Wolaver's Organic brand. It was these partnerships that the Wolavers used to work with other brewers around the country. This also helped Otter Creek get access to distributors in other states.

KROSS BREWING
November 1998

Kip Ross and Jim Cadieux worked hard to adapt the old Cabot Creamery into a brewery in Morrisville. They were also way ahead of their time by focusing their brewing on Belgian-style beers. For many Vermont beer drinkers, Ross's and Cadieux's beers were their first taste of the Belgian style, and given the accolades the brewers received, they were doing something right. Their beers received high praise in the media and were sought after by beer enthusiasts, but production issues led to inconsistencies in packaging. On a number of occasions, bottles became over-carbonated.

MAPLE LEAF MALT AND BREWING COMPANY
January 1999

John Foote had a wonderful location for his Maple Leaf Malt and Brewing Company at the intersection of Routes 100 and 9 in Wilmington. It was just a short ride up 100 to Mount Snow, and Route 9 is the major east–west crossing between Bennington and Brattleboro. This was a great pub with a laidback atmosphere drawing both locals and tourists alike. This started out as a three-barrel New World system but was added to with subsequent owners.

10

1996–2000

UNPRECEDENTED GROWTH AND A SHAKEOUT

Steve Godfrey announced the Hinesburg Brewing Company, and it leased 21,600 square feet of space in Milton; however, nothing ever materialized.

McNeill's doubled capacity to two thousand barrels and added two ten-barrel fermenters and two conditioning tanks. It also expanded their self-distribution. In 1996 at the World Beer Cup and in 1997 at the Great American Beer Festival, Alle Tage Altbier won silver medals. In 1998, McNeill's expanded its brewhouse to ten barrels, making thirty different beers per year. The brewery contracted with Catamount Brewery to bottle six-packs of Firehouse Amber Ale, Blond Bombshell and Champ Ale. Ray promised that the extra capacity would be devoted to lagers.

During 1995 and 1996, the Joseph Cerniglia Winery in Proctorsville produced Hart's Bend Amber Macintosh Beer. This was a partial malt beverage brewed with apples, but a brewery named Hart's in Washington State objected to the name. The winery sold out of the remaining inventory of the brand and focused on its Woodchuck Draft Cider.

Greg Noonan issued an expanded and revised edition of *Brewing Lager Beer*. The new book was over one hundred pages longer and included updated and revised material. *The New Brewing Lager Beer* was eagerly received and became one of the bestselling books published by the American Homebrewers Association. Greg also received a Special Recognition Award from the association.

In 1997, Magic Hat Brewing settled on a new location on Bartlett Bay Road in South Burlington and began construction of a state-of-the-art brewery on

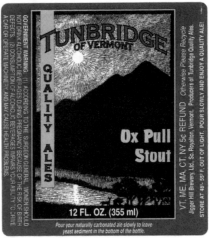

Notice the top of the mountain for the Winter Expedition. *Collection of Toby Garland, photo by Kurt Staudter.*

the old Grossman's Lumber property. It was the brewery's aim to bring all the bottling operations being done in Maine to Vermont. The brewery on Flynn Avenue remained to continue the kegging operations. When the new location was completed, all Magic Hat beer was made in Vermont. The new brewery was designed by Rick McCann and had four one-hundred-barrel and two fifty-barrel fermenters, three one-hundred-barrel and two fifty-barrel conditioning tanks and a high-speed Krone bottling line. Magic Hat hoped to increase output to sixty or seventy thousand barrels per year in the new facility.

Jigger Hill Brewery celebrated its first anniversary in 1997 with a homebrew competition. The winner got to brew the Tunbridge Quality Ales World's Fair Special for the fair that year. In 1998, Jigger Hill changed its name to Tunbridge Brewing and built an expanded fifteen-barrel brewery in a ten-thousand-square-foot space in South Royalton.

The Vermont Brewers Festival in 1998 included colonial reenactments of tavern life and brewing, cooking demonstrations with the New England Culinary Institute and thirty-five brewers and over one hundred beers.

Franklin County Brewery began shipping its Rail City Ale in six-packs. Golden Dome was shipping twenty-two-ounce bottles of Ceres Back Forty. Otter Creek shipped its Oktoberfest in bottles for the first time in 1996. The Shed and Three Needs began selling growlers at package stores in 1997.

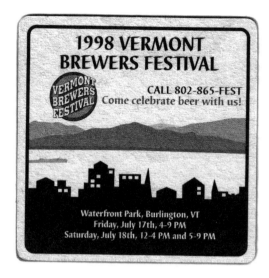

Above: Before there was Guinness on nitro, there was Golden Dome. *Collection of Toby Garland, photo by Kurt Staudter.*

Top: Come celebrate with us on the west coast of New England. *Collection of Toby Garland, photo by Kurt Staudter.*

Madison Brewing bottled its Sucker Pond Blond, Old '76 Strong Ale, Willoughby's Scottish Ale and Smoker's Den Smoked Amber Ale. The brewery also shipped to draft accounts in order to make full use of its brewhouse.

John Kimmich left the Vermont Pub & Brewery to work on a couple brewery projects out west, though he eventually returned to Vermont. He was replaced by Jonathan Kusmin. Over at Golden Dome Brewing, cofounder Ian Dowling left, forcing a short shutdown and restructuring at the brewery. Dan Young left the Windham Brewery to start the People's Pint in Greenfield, Massachusetts, and was replaced by Michael Fulton.

Black River Brewing in Ludlow reported production was up 60 percent in 1997 and added brewer Dave Braid to the payroll. The brewery's three-barrel system was another example of Yankee ingenuity.

In 1998, the Windham Brewery owner Spiro Latchis's brother-in-law Alan Eames, author of *The Secret Life of Beer* and often referred to as the "Indiana Jones of beer" for his anthropological

work, decorated the wall with an amazing mural and display on the history of beer and the process of brewing.

By 1998, a movement within the craft beer movement saw more brewers producing casks of beer. This time-honored approach to beer making, also referred to as "Real Beer," calls for beer to be conditioned in a cask. The beer is either served from a spigot by gravity or by hand-pulled "Beer Engines." It is usually served warmer at "cellar temperatures" and is often not as carbonated. Brewers making casks included McNeill's, Vermont Pub & Brewery, Long Trail and Magic Hat.

Golden Dome struggled after its restructuring, and in August 1999, after five years of operation, Russ FitzPatrick decided to call it quits. The equipment was auctioned off with much of it being sold to Liz Trott of Tunbridge Brewing.

A fire next door to Kross Brewing in Morrisville delayed an expansion for the brewery. Russ FitzPatrick went to work for Kross. Otter Creek and Long Trail expanded their distribution. Long Trail broke out of New England with beer being sold in New Jersey.

Bennett Dawson of Franklin County Brewing had a hard time in 1999, and by the end of the year, he was running the brewery by himself. He got help from Otter Creek and Magic Hat, and there was talk of distribution into New York. In 1999, he shipped 1,400 barrels and began to look at other locations, perhaps some sort of partnership with a restaurant.

Production was up at both Rock Art Brewery and Trout River Brewing. Rock Art added more equipment, and Renée Nadeau went full-time into sales. Trout River saw production go from 850 barrels in 1998 to 1,200 barrels in 1999.

Glenn Walter of Three Needs won a bronze medal for his Schwartzbier at the Great American Beer Festival. Brad Ring, the publisher of *Brew Your Own* magazine, the premier journal for homebrewers, moves the business from California to Manchester.

CATAMOUNT STRUGGLES

1999

Servicing the $5 million debt on the new brewery proved to be too much for the once mighty Catamount. During the time that the brewery believed it would see unlimited growth, it instead saw a combination of flat sales and competition from other brewers looking for shelf space.

Catamount's move to Windsor brings more beer but bigger problems. *Collection of Toby Garland, photo by Kurt Staudter.*

Earlier in the year, Catamount announced some new beers, including Northern Bright. This was a beer that had the backing of the investor-led board of directors, but very few people on the brewing side of the business liked the beer. It was a departure from the wonderful beers that had built

the reputation of the brewery. The beer was a pale golden beer that was intended to compete with the likes of Corona, Budweiser and Miller. This rift between the marketing side of the house and the brewers led to the dismissal of Steve Mason as the CEO and his replacement with Paul Ralston. Paul had been brought into the company with the move to Windsor as a marketing consultant.

In a number of interviews, Paul Ralston sounded desperate, telling beer drinkers basically to buy a six-pack and save Catamount. With cuts in the brewing operations, layoffs and eventually just brewing to order, the writing was on the wall. Northern Bright wasn't going to be the beer that saved the company; instead, it alienated the folks who made the brewery successful in the first place. With the reduced distribution of the Catamount brands, there were many breweries looking to pick up Catamount's shelf space at the package store or on tap handles in bars.

HARPOON BREWERY

June 2000

A state-of-the-art facility, a local workforce trained in brewing operations and a fire sale price made it only a matter of time before someone cut the padlock that Chittenden Bank had put on the Catamount Brewery back in April. On June 29, a deal was reached with the bank, and for just $1 million, Harpoon Brewery was able to pick up the brewery and rights to the Catamount brands. An agreement had been announced earlier in the month, but leading up to the closing, there had been a lot of speculation as to the fate of Catamount. Those folks who had joined the craft beer movement by becoming fiercely loyal to the Catamount brand were wondering what Harpoon would do with the Catamount recipes. Having been around since 1987 as well, Harpoon understood the responsibility it had to the Catamount fans, and it pledged to resurrect the beers.

This was a great deal for Harpoon. The brewery in Boston had a limited amount of space, but the location was on the waterfront in a neighborhood that was being revitalized. For the brewery to have expanded its operations as much as it did with the Catamount purchase would have taken an investment many times the cost that the brewery paid for Catamount.

This was the best of both worlds for Harpoon—the Boston brewery was nearing capacity at sixty thousand barrels, and the Windsor brewery almost doubled that at fifty thousand barrels. During a period when most craft brewers saw sales stagnate or decline, Harpoon saw a 20 percent increase, and now it was entering a market in Vermont, which had proven to be fertile ground for craft brewers.

For those of us who had the world of good, local beer opened up to us by Steve Mason and Catamount Brewery, the arrival of Harpoon into the Vermont brewing community was indeed welcome. There were many ways in which the failure of Catamount could have ended badly. The site could have remained empty and the brewing equipment could have scattered to the winds. Instead Vermont ended up with one of the rising stars in the movement, and as time went by, Harpoon ended up becoming a model corporate citizen while continuing the tradition of making great beer in Vermont.

WOLAVER'S ORGANIC

May 2002

Panorama Brewing and the Wolaver brothers had seen their brand grow to 5,200 barrels in 2001, and 1,500 barrels of that had been brewed in Middlebury. Following the business model of contract brewing with regional partners had served the Wolavers well, and their focus on marketing a brand with a mission statement that in many ways is in sync with other iconic Vermont products helped make theirs the top-selling organic beer in the country. After more than a decade of building Otter Creek Brewing into one of the top fifty breweries in the country with twenty-five thousand barrels of output in 2001 of its forty-thousand-barrel capacity, brewmaster and founder Lawrence Miller began to weigh the chaotic life he was leading with being able to enjoy time with his family. As is the case with many of the Vermont brewers, his family came first.

Over the years, Lawrence had been approached to sell the brewery, and while some of the offers were quite tempting, he wasn't ready to let go yet. There were offers that would have helped propel the Otter Creek brand to unimaginable levels; others were from companies that didn't quite share his

values, and some wouldn't have treated the employees who built the business the way he wanted. However, he finally made the decision and went to Morgan Wolaver to let him know.

Given the kind of growth Panorama Brewing was seeing, the board of directors was going to look at building a brewery of its own. When the board was presented with the prospect of purchasing the Otter Creek brewery, it was a match made in heaven. Here was a company that included in its mission statement some of the same values that had guided Lawrence Miller, and there was a promise that all thirty-six of his employees would keep their jobs with the new company. This move opened up Otter Creek to Wolaver's Organic distribution network and became a mutually beneficial merger.

SWITCHBACK BREWING COMPANY

October 2002

Brewmaster Bill Cherry had the recipe for Switchback Ale in his head before he brewed the first drop. After being convinced by his friend and co-owner, Jeff Neiblum, to open a brewery, Bill started to go over in his imagination different possible recipes for his Vermont Ale. But don't try this mind exercise at home, it's best left to trained professionals—Bill is a graduate of the UC–Davis brewing program and had worked as a brewer before coming to Vermont.

For the longest time, Bill Cherry was a one-man show. To this day, restaurant and bar owners still talk about how he would not only brew the beer but also promote it. After an initial success when the beer was introduced, sales flattened out. With just a few more months of money left, it was decided that in addition to the 15.5-gallon kegs, Switchback would begin to offer smaller kegs. This proved to be a stroke of genius. Bars unwilling to put on a full keg of this new beer were less reluctant to do a small keg. Soon, the beer was in demand, and Bill was thinking about getting some help. Chris Dooley, Gretchen Langfeldt and Tony Morse were added, along with more fermenters, by 2006.

One of unique things about all the beers that come from Switchback is that they are naturally carbonated. Just like bottle conditioning, Bill lets the yeast do the last little bit of work in carbonating the beer. Most commercial

breweries do what is called "forced carbonation," where carbon dioxide is introduced into the beer. Another thing about Switchback that is special is the fact that the brewery still uses the original strain of yeast that has been propagated since the beginning. This takes constant vigilance and is what helps make Switchback so unique.

Kingdom Brewers

March 2003

Way up in the Northeast Kingdom, there is a little town outside East Burke called Victory. In perhaps one of the most interesting brewing startups, Kingdom Brewers was going to brew beer "off the grid." The husband-and-wife team of Glenn and Carole Shepard brewed its beers with a gravity-fed well and propane burners in the town of Victory. Bowman's Reserve Porter was the brewery's flagship beer, and by October, there were plans to add to the brewery. Two fermenters and a condition tank were purchased with the additional financing that the Shepards were able to raise, and they were going to be distributed by Farrell Distributing in South Burlington. The twenty-two-ounce bottles of porter were well crafted and seemed to be selling, but being off the grid proved to be a better marketing tool than a way to run a brewery.

Peavine Restaurant & Thirsty Bull Brew Pub

May 2003

Owner Bryan Mattson briefly flirted with the idea of adding a brewery to his restaurant and even enlisted the help of veteran brewer Liz Trott. The Stockbridge restaurant brewed a few batches of beer, but around the same time that word spread that the restaurant was brewing, it stopped.

BOBCAT CAFÉ

June 2003

Being somewhat without direction as a college student, Paul Sayler had found something that truly fascinated him: brewing beer—which was interesting because, other than brewing, he was somewhat without direction. This passion for brewing led to a college project on yeast that caused him to interview a number of brewers, including Steve Mason of Catamount. Paul was offered an opportunity to participate in the Catamount apprenticeship program, and after three months, he was offered a job. His career in brewing continued with a relationship with Commonwealth Brewing Company, where, after a brief stint in Massachusetts, Paul headed up the effort to open a brewpub for Commonwealth just off Rockefeller Center. For three years, he worked in New York City, but he eventually came to Vermont to work with his

This brewhouse was originally the Franklin County Brewery and now is in the Bobcat Café. *Photo by Paul Kowalski.*

friend Rob Downey to open a Burlington Hearth of American Flatbread that would include a brewery.

After a number of false starts and potential locations that fell through on their Flatbread project, Paul and Rob became partners, along with restaurateur Robert Fuller, in the Bobcat Café. The Bristol brewpub also received help from the community when thirty-two local investors all made $5,000 pledges to the project. In exchange for the investment, they would be able to get a steep discount on meals, and their loans would be paid back in five years.

Paul, Rob and Robert initially set up the brewhouse purchased for the Burlington Hearth in Bristol, but it was replaced by the ten-barrel brewhouse with tanks from the now defunct Franklin County Brewery, and Bennett Dawson came to help set it up. Paul brewed at the Bobcat while working to finalize plans for the restaurant in Burlington. Although the Bobcat opened in April 2002 and the brewery was ready for operations by the fall, it wasn't until the following summer that its beers were served. After Paul left in 2005, he was replaced by Ron Cotte.

What the Bobcat Café proved was that even in a small Vermont town there was enough interest to sustain a brewpub. There were other factors, such as the café's commitment to using local ingredients in the exquisitely prepared foods and the reasonably priced menu, that contributed to success. Perhaps another reason for the success was the proximity to Middlebury and Lincoln. However, let's not dismiss the fact that between Paul Sayler, Ron Cotte and later Mark Magiera, the Bobcat Café has always had some really great brewers.

Alchemist Pub & Brewery

November 2003

If you didn't get to the Alchemist Pub at 4:00 p.m. when it first opened, you were going to have to wait. That was how popular the place that John and Jennifer Kimmich opened in Waterbury had become before Tropical Storm Irene. The beers were always interesting, the food was wonderful and the presentation was elegant. Everything about this pub was built on the experience of a couple who had paid their dues in the restaurant and brewing business. Once you did get a table, it was hard give it up—the place

just felt comfortable, and between the food and beer, along with pleasant company, you would lose track of the world around you.

The Alchemist Pub was one of a growing number of restaurants that were part of the Vermont Fresh Network. The pub's commitment to using local ingredients, along with talented chefs, kept the menu changing with wonderful things to try each time you visited. While Jennifer kept the food side of the house in order, John went wild in his own brewery.

Once again it is important to remember that John Kimmich didn't just appear out of nowhere making world-class beers. The wonderful diversity and the depth of his repertoire came from years of brewing for Greg Noonan at the Vermont Pub & Brewery. The beer list at the pub was always changing, and the styles being offered were limited only by John's imagination. There were some house beers that emerged as regulars, but one beer became legendary: John's double IPA, Heady Topper.

11

2000–2005

BREWING A WORLD-CLASS REPUTATION

In January 2000, Long Trail brewed its 2,000[th] batch. Franklin County Brewing sent its Rail City Ale to Syracuse and Albany and talked of purchasing a bottling line. Maple Leaf got serious about its beer and hired UC–Davis grad Jeff Starratt to take over the brewery.

Trout River moved from Burke to Lyndonville and purchased a twenty-barrel brewhouse from the Firehouse Brewery in Florida. The new location included a tasting room and offered pizza on Fridays and Saturdays. The four-barrel system in Burke continued to brew double batches and seasonals. Dan Gates predicted that production would reach six thousand barrels. The new location was a health club in the 1980s, and half of the former swimming pool became the location of the brewhouse, while the other half was covered over for the bottling line.

Magic Hat released a nine-pack of Fat Angel. Otter Creek shipped its first variety pack and began distributing to North Carolina and Pennsylvania. Rock Art began distributing growlers. Tunbridge announced a partnership with the J. Lewis Company to brew a gay pride beer called Vermont Pride Ale to raise money for AIDS awareness and medical programs. While Tunbridge started shipping to western Massachusetts, added J.N. Ridgeway as a brewer and purchased new tanks, it contracted out Vermont Pride Ale to Shipyard.

Three Needs brewer Dan Lipke and owner Glenn Walter began to bottle-condition Belgian ales and obtained yeast to experiment with lambics and other sour ales. Kip Ross of Kross Brewing won silver in the 2000 World Beer Cup for his Brueghel Blonde Ale.

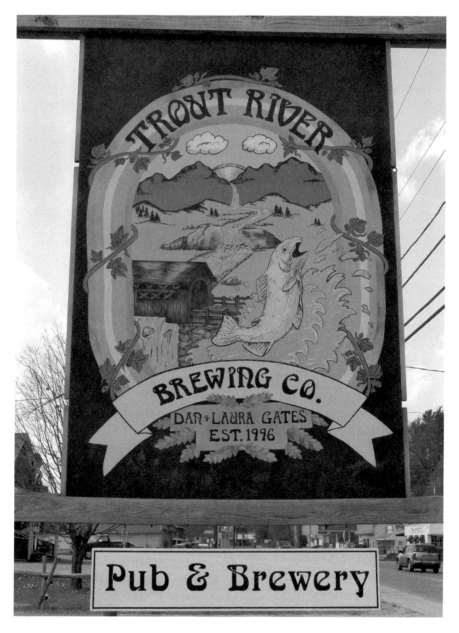

The Northeast Kingdom is a little out of the way, but worth the trip. *Courtesy of Vermont Brewers Association.*

Long Trail Brewing expanded its capacity to 45,000 barrels per year with the addition of two 120-barrel tanks. Elsewhere in Windsor County, Black River Brewing opened its Proctorsville location after having closed the Main Street Ludlow pub. During the delays between the closing and the opening, brewer Tom Coleman helped out at the Tunbridge Brewery.

Not to be outdone, Otter Creek celebrated its tenth anniversary with an expansion that included two two-hundred-barrel fermenters, some eighty-barrel conditioning tanks, a forty-barrel whirlpool and updates to packaging.

By the end of 2000, Bennett Dawson had closed Franklin County Brewing, citing distribution issues. The brewery was sold eventually to Paul Sayler to be installed at the Bobcat Café. Also closing in 2000 was Tunbridge Brewing. Liz Trott cited health problems as she shuttered the brewery, and the brands were contract brewed by Shipyard. The equipment was sold in April 2002.

Executive Director Willie Docto of the Vermont Brewers Association announced a partnership with the Vermont Agency of Agriculture, the Department of Tourism and the wineries of the state to produce a brochure for the state rest areas. It quickly became the most popular of the state's brochures.

In 2001, Black River Brewing reported that sales were up over 20 percent compared to its old location and expanded its brewhouse to fifteen barrels. Harpoon brewery held the first New England Barbecue Championship in Windsor. Maple Leaf was sold to Jason Meyers, who continued the brewing.

Rock Art Brewery moved into a space next door to Kross Brewing in Morrisville and expanded. The brewery bought the old Catamount bottling line from Harpoon and added two fifteen-barrel conical fermenters. Before leaving its Johnson home, the brewery had brewed twenty-five thousand gallons of beer.

Magic Hat began a tradition of political activism in 2000, encouraging people to get out to vote with its Participation Ale. After the election, Vermont senator Jim Jeffords cited ideological differences with the Republican Party and announced that he would leave the party and become an independent. This flipped the balance of power over to the Democrats. Magic Hat brewed a beer to honor the senator called Jezzum Jim Ale and lost two accounts due to ideological differences.

The Vermont Brewers Festival grew 21 percent under the leadership of Willie Docto and hosted 5,200 beer enthusiasts at the Burlington waterfront. In 2002, the festival drew 5,800 people. Harpoon brought its successful Boston Oktoberfest to Windsor for the first time and won a silver medal at the Great American Beer Festival for its Munich Dark. Madison Brewing had its biggest year ever with 13 percent growth and is named one of the top

Magic Hat thanks our senator. *Photo by Kurt Staudter.*

eateries in New England by *Yankee Magazine.*

In early 2002, Magic Hat held its seventh Mardi Gras, and more than twelve thousand people turned out on the streets of Burlington. Long Trail invested in a state-of-the-art wastewater plant, setting the bar high for brewery water management. In another water-related issue, Trout River Brewing flooded in June, but there was minimal damage. Greg Noonan took over from Nancy as spokesperson for Vermont Pub & Brewery, and she devoted her time to Seven Barrels.

Steve Miller was head brewer of Vermont Pub & Brewery, and Russ FitzPatrick took the assistant brewer job. Jeff Hughes came from Saratoga Brewery to take the reins at Three Needs, but he was replaced by J.T. Tierney by the beginning of 2003.

Kross Brewing got a new distributor in New Jersey and Pennsylvania. Rock Art bought a forty-barrel fermenter and a forty-barrel conditioning tank. Paul Sayler of the Bobcat Café began to brew test batches in the summer of 2003 and announced that it would pour its beers by the fall. Unfortunately the café ended up having to destroy the beer because of a misunderstanding with Vermont Department of Liquor Control.

Otter Creek won a gold medal for its Copper Ale in 2003 at the Great American Beer Festival, and Vermont Pub & Brewery won silvers for New World Silk and Bombay Grab IPA, as well as bronze for Dogbite Bitter at the World Beer Cup in 2004. In the 2004 Great American Beer Festival, the Alchemist won for its Sterk Wit, a Belgian-style strong ale.

In 2004, Vermont Pub & Brewery increased capacity by 20 percent with the purchase of four fermenters and two serving tanks. Rock Art

Above: The corner of College and St. Paul Streets on a beautiful day—just add beer! *Courtesy of Vermont Pub & Brewery.*

Left: This is an example of the simple packaging that Long Trail would use for experimental beers. *Collection of Toby Garland, photo by Kurt Staudter.*

celebrated its second year in the new brewery and introduced twenty-two-ounce bottles. Its "Extreme" beers were brewed right up to the 8 percent alcohol by volume limit mandated by the state and became a huge hit. Madison Brewing begins to bottle some of its beers, including Old '76 Strong Ale. Long Trail expanded its visitors' center with upgrades to the kitchen, restaurant and deck, making it one of the most wonderful locations to enjoy a beer.

In what became the beginning of the heyday at Maple Leaf in Wilmington, Darren Fehring and a partner purchased the pub. Darren was an accomplished brewer from Key West Brewing Company who brewed the holiday beer served at the Clinton White House before coming to Vermont. He and his partner searched all over before setting on Vermont. While Darren brewed an exciting range of beers, including long-forgotten German styles, his heart remained in the tropics. He amazed the locals with his long hair and Grateful Dead tattoos and by dressing in flip-flops and shorts even on the most brutal winter days. He prided himself on never brewing the same recipe twice, and he helped along other brewers, including giving Tim Wilson his break. Tim now brews at Jack's Abbey in Framingham, Massachusetts.

American Flatbread/Zero Gravity Craft Brewery

April 2005

When Paul Sayler and Rob Downey set to finding a place to open the Burlington Hearth of American Flatbread originally, it was going to be part of a much larger waterfront development. That project got bogged down with regulatory delays that eventually went all the way to the Vermont Supreme Court, but it did give them time to open the Bobcat Café. Eventually, they settled on a location in a great old building across from City Hall Park that had previously housed a restaurant and, in the 1800s, a patent medicine factory. Using the space presented a number of challenges, including the weight of the hearth, plumbing and electrical upgrades and installing the brewery.

The ten-barrel Newlands Systems brewhouse was put to work making house beers, and in addition, the long row of taps featured other great beer

Destiny Saxon and Paul Sayler push the envelope of Zero Gravity. *Photo by Kurt Staudter.*

from all over the country. Then there was the bottle list. After the café opened, this became the mecca for beer enthusiasts. The rare and hard-to-find bottles, guest taps and exquisitely crafted Zero Gravity beers set the standard for beer bars in Vermont. At the time, bar manager Jeff Baumann was developing relationships with distributors and brewers to bring beers to the bar that were available nowhere else in the state. Bartender Chad Rich learned well under Jeff and went on to be bar manager at the Farmhouse Tap & Grill, but he really realized his full potential when he opened a place of his own.

While Paul started out by handling the brewing operations, his other projects cut into what time he could devote to it, so he knew enough to bring on an assistant. Destiny Saxton had worked at Otter Creek Brewing and had attended the Siebel Institute of Technology for one of the oldest brewing programs in the nation, and she basically harassed Paul until he hired her to help install the brewery. Before too long, Paul made her head brewer, but he still remains as a creative force between his other responsibilities.

HORNPOUT BREWING
May 2005

The brewing equipment that was left behind with the demise of Kingdom Brewers was picked up by Kathy Davis and John Eastman and moved down to Lyndonville. Keeping their day jobs, the Eastmans built Hornpout Brewing into a nice little brewery with a number of beers distributed with Farrell. Their beers available in twenty-two-ounce bottles and on draft included No Limit Amber Ale and Muddy Bottom Porter. This endeavor was only around for a short while.

GRANITE CITY BREWING/ STONECUTTERS BREWHOUSE
April 2007

This was a brewery that was plagued with problems from the get go. Bud Steven was an avid homebrewer who went into the business of providing homebrew supplies in the Barre area in order to lower his costs, figuring that buying bulk grains and hops would help not only himself but also other homebrewers. Soon, he was purchasing enough to provide for the needs of local homebrewers as well as for him and his brother Jason to open a pub. They set up a two-barrel system with open fermenters and started brewing Granite City Big Ale.

Granite City Brewing had not been open for even a year before it was hit by a double whammy. First, it found out that its name was already happily in use by Granite City Food and Brewery in the Midwest, and then in the fall, there was a kitchen fire. The fire in late 2007 closed the brewpub for two months, but it reopened in January 2008 as Stonecutters Brewhouse. Next, the brewpub heard from Hyzer Industries, a Vermont company, that it had licensed the name Stonecutters Pub & Brewery. Stonecutters lasted for a little longer than a year, closing in February 2009. Bud Stevens indicated that perhaps he would try again someday. Scott Kerner of Hyzer Industries, with partners Wes Hamilton and Mathew McCarthy, went on to open the Three Penny Taproom in Montpelier in 2009, and it became one of the best beer bars in the state.

Lawson's Finest Liquids

March 2008

Laidback is the only way to describe Sean Lawson, except when it comes to beer. His passion for the art and science of brewing burns inside him like a white-hot supernova. An award-winning homebrewer with eighteen years experience with time spent at Breckenridge Pub and Brewery in Colorado and Beaver Street Pub and Brewery in Flagstaff, all Sean needed was the encouragement of friends and family to build the Sugarhouse Brewery on his Warren property. The MoreBeer brewing system with a Blichmann kettle made one and a half barrels of beer, and he hand packaged and self-distributed all of his beers. Sean was nano before nano was cool.

Along with his wife, Karen, he is a fixture at local farmers' markets, and his bottles often sell out within hours after delivery. Kegs of his beer make their way into some of the hottest beer bars in the state. As his reputation has grown as a brewer, he eventually has been forced to devote all of his time to the brewery, although he still keeps his job as the Mad River Glen naturalist.

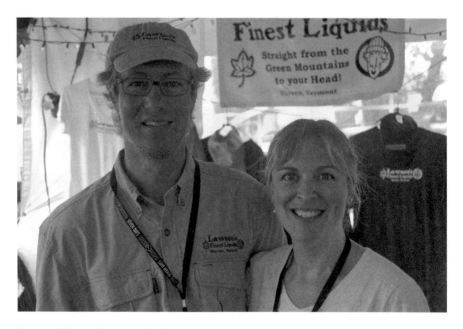

Sean and Karen Lawson take a break between sessions at the Vermont Brewers Festival. *Photo by Kurt Staudter.*

His beers stake out new territory at the top end of small batch beers. The limited runs and local distribution fueled by wonderful reviews have given Sean the ability to fetch top dollar for his beers. It also has helped that many of the early bottles were hand numbered and signed. This added to the mystique surrounding Lawson's Finest Liquids. However, it is his expertly crafted beers that have won awards and the hearts of beer enthusiasts. It wasn't long before he graduated to a slightly bigger brewery.

12

2005–2010

FERMENTING THE VERMONT BEER MYSTIQUE

During 2005, Harpoon completed an expansion from 35,000 to 65,000 barrels that included six 250-barrel unitanks, a 400-barrel bright tank and improvements in filtration equipment. Otter Creek installed new energy-efficient refrigeration equipment that would reduce energy use by seventy-five thousand kilowatts per year. Rock Art expanded from a 7-barrel system to 22-barrel brewhouse and began to sell twelve-packs while distributing to New Jersey. Vermont Pub & Brewery put in 14-barrel brewhouse. Long Trail began brewing four 60-barrel batches a day and updated its lab while adding two more 120-barrel fermenters.

The real beer movement began to catch the imagination of brewers, and more have begun offering casks. Cask beers are available at McNeill's, Vermont Pub & Brewery, Otter Creek, American Flatbread/Zero Gravity, the Shed, the Alchemist and Maple Leaf.

During the 2006 legislative session, the Vermont Brewers Association held a legislative reception that presented thirty beers, food and jazz. Executive Director Willie Docto pointed out that there was no agenda. The Vermont legislature said thanks by ending the sales tax exemption on beer that added forty-five cents to the cost of each six-pack.

Vermont brewers have become model corporate citizens with their fundraising efforts. Otter Creek, Long Trail, Magic Hat and Harpoon all have programs that raise money for worthy causes. In 2005, Harpoon raised $13,000 for the Vermont Food Bank with its point-to-point bike ride.

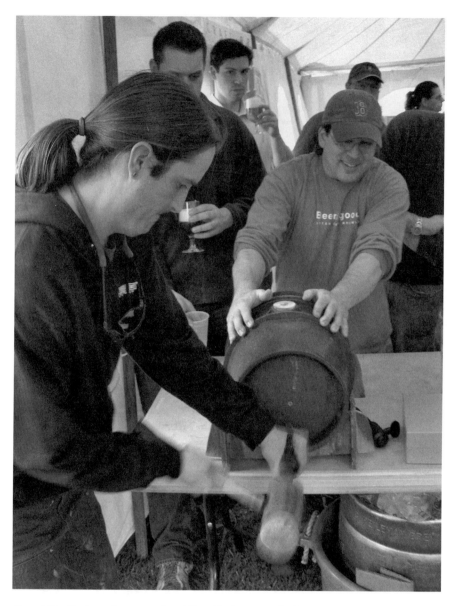

Above: Mike Gerhart (foreground) and Ron Cotti tap a cask. *Photo by Paul Kowalski.*

Opposite: Shaun Hill, from bottle washer/filler to head brewer. *Courtesy of Shaun Hill.*

Switchback Brewing briefly got into bottling with 750 milliliter flip-top bottles. The brewery bottled 1,800 bottles in 2005 and 2,700 bottles in 2006. This labor-intensive process with only three employees proved to be too much and was quickly abandoned. Bill Cherry began to work on the Roasted Red and presented it for the first time at the Vermont Brewers Festival.

After Shaun Hill took over as brewer at the Shed, he offered an impressive number of different styles and introduced Vermonters to saisons. He began to brew a new Belgian style every week as he got into the rhythm of juggling the demands of the pub and distribution. After he added Jim Conroy as an assistant, he was free to be very creative. By the beginning of 2007, Shaun was thinking of opening his own brewery and left to work at Trout River to gain experience at a production brewery while he worked out the details.

Rock Art Brewery saw sales up 25 percent and invested in a sixty-barrel bright tank and a sixty-barrel hot liquor tank. It began now distributing in Massachusetts, Connecticut and New York City.

Paul Hale won the Green Mountain Mashers Homebrew Contest and brewed a batch of the winning brew at the Vermont Pub & Brewery. He went on to win a number of times.

Glenn Walter has always marched to a different drummer. During the 2006 Vermont Brewers Festival, he served a single beer—a lambic. This was

well before most folks were brewing sour beers, and he was just sitting there with a Cheshire cat–like grin, serving up a beer that he knew would blow people away.

Steve Miller left the Vermont Pub & Brewery and was replaced by Russ FitzPatrick. By 2007, Hornpout and the Windham Brewery were no longer listed as breweries.

In 2007, the Vermont Brewers Association got to work on changing the 8 percent alcohol by volume cap. All around the country, craft breweries were pushing the limits of the art by brewing bigger and hoppier beers, but here in Vermont, brewers were hamstrung by this arbitrary limit that was a throwback to the post-Prohibition days. In one example of how the law hindered the breweries, Rock Art brewed the Vermonster for its tenth anniversary, but because it came in at 10 percent ABV, you could only buy it outside Vermont or at the state liquor stores. The brewers came together and

approached the legislature with a unified voice. In the first half of the biennium, the House passed H.94 lifting the cap to 16 percent, but the legislation stalled in the Senate. The bill got through the Senate during the 2008 session and became law without the signature of Governor Jim Douglas. The collective action of Vermont brewers to change this legislation was an important milestone for brewing in Vermont.

Even the growler design was handled by Greg Noonan. *Photo by Kurt Staudter.*

Vermont Pub & Brewery added four fermenters and doubled cooling capacity, and Russ FitzPatrick took over as head brewer. Long Trail expanded capacity to eighty thousand barrels per year. This represented a 30 percent increase and more than five thousand cases per week. Otter Creek went greener by sourcing bottles closer to Middlebury, using biodiesel for the boiler, reducing the labels on the bottles from three to two and using unbleached or recycled paper for its packaging.

Magic Hat launched the Orlio Organic Beer Company. This beer capitalizes on the growing interest in organic beers, but the brewery only stayed with the brand for a few years.

Quietly in 2006, Andy Pherson decided that, after seventeen years, he had had enough and sold Long Trail Brewing to Fulham and Company, a private equity firm out of Boston with family ties to the fishing industry. Dan Fulham appointed longtime beer executive Brian Walsh as chief executive officer. Although this was big news, it was all but ignored in the media, and the new owners quickly demonstrated that they were working hard at improving on what Andy had built. They also distinguished themselves as model corporate citizens and leaders in running an environmentally friendly brewery.

In 2007, the Vermont Brewers Association launched the "Vermont Brewery Challenge." This beer trail–passport program asks beer enthusiasts to visit breweries, get their passports stamped and send them in for prizes, including a "collector's set of beer gear," for visiting all the breweries. While over the years the number of breweries needed for the prizes has gone from sixteen to over thirty, each year more people turn in the passports. In 2013, there were over one thousand redemptions. In the fall, Ray McNeill was one of five brewers invited to speak at the Smithsonian Resident Associate Program at the Smithsonian Institute. He announced at the end of the year that he was going to build a production brewery.

During 2008, Magic Hat made an offer on Pyramid Breweries, offering to buy two-thirds of its outstanding shares and take on its accumulated debt. In total, the deal cost $35 million and was put together by Magic Hat CEO Martin Kelly, who ran Pyramid from 1999 to 2004. Never really happy in the cold north, Darren Fehring and his partner, Mark Marchionni, sold Maple Leaf to an owner who didn't want the brewery. Darren took some of the equipment to Florida, and he opened the successful Mad Crow Brewery & Grill in Sarasota. Unfortunately, he died a few years later.

In June 2008, coauthor of this book Kurt Staudter was hired as executive director of the Vermont Brewers Association, replacing Willie Docto, who had held the position since 1999. Willie went on to focus on the festival, and together with his wife, Patti, Kurt took up the day-to-day operations of the association.

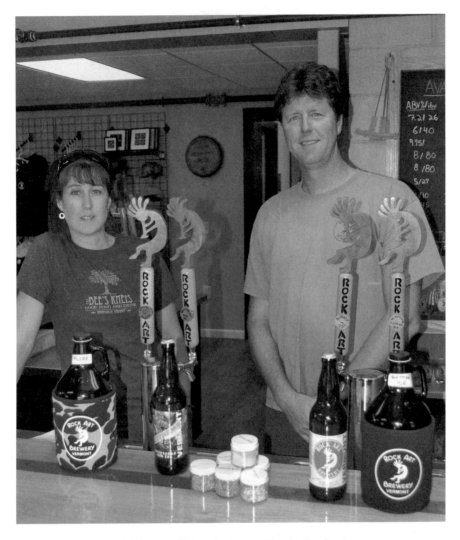

Above: Renée and Matt Nadeau are living the dream. *Photo by Kurt Staudter.*

Opposite: Greg Noonan (left) and Steve Polewacyk take a break in the office. *Courtesy of Vermont Pub & Brewery.*

By 2009, despite the sharp downturn in the economy, Harpoon Brewery made a seven-figure investment in its Riverbend Taps. The new visitors' center and grill were huge successes and greatly exceeded the company's expectations. Ron Cotti took a brewers job at Otter Creek and was replaced at the Bobcat Café by Mark Magiera. According to head brewer Ryan

Ahearn, McNeill's was bottling three times per week at the new brewery. Berkshire Brewing of Deerfield, Massachusetts, opened the Flat Street Pub in the former Windham Brewery but did not brew there. Long Trail won the Governor's Award for Environmental Excellence and pioneeed its Eco Brew, or Environmentally Conscience Operations. Stonecutters got into a landlord dispute and was closed for good. Switchback began to brew a porter.

On September 14, 2009, Rock Art Brewery got a letter from the manufacturers of the Monster energy drink to cease and desist using the name Vermonster. According to the Hansen Beverage Company, the small Vermont beer company was infringing on its trademark. After being advised by his lawyer that he didn't have the resources to fight the mega-corporation, owner Matt Nadeau took to the Internet and social media with his story. In a classic David versus Goliath showdown, hundreds of folks went to the Hanson website to complain, the mainstream media picked up the story and even the company's stock took a hit on Wall Street. Within twenty-one days, Hanson CEO Rodney Sacks and Matt Nadeau came to an agreement in which Matt promised not to make energy drinks and kept the Vermonster name.

On October 11, 2009, the brewing community was shocked to find out that the godfather of Vermont beer, Greg Noonan, had died. After a brief battle with cancer, the brewing legend is remembered as a pioneer for his efforts to change the laws in Vermont that enabled him and those who came after him to open

brewpubs. The significance of his contributions cannot be overstated. Because of Greg, Vermont is a destination for our thriving beer scene, and because of his writings, we all make better beer. While Steve Polewacyk has done an excellent job of keeping the Vermont Pub & Brewery as a premier brewpub, there will always be an absence at the bar where Greg was known as the ultimate publican. Greg was always willing to spend hours talking about beer with strangers and eagerly excited to taste with you the latest beers coming from his brewery.

TRAPP LAGER BREWERY

January 2010

It had been the dream of Johannes von Trapp to have a brewery up at the Trapp Family Lodge in Stowe. In this dream, he would have handcrafted Austrian-style lagers served to the guests and then the rest of New England. In fulfilling this dream, Johannes, along with his son Sam, cautiously invested in a two-thousand-barrel-per-year brewery, hired

The balance of power begins to tip to the German styles in Stowe. *Photo by Kurt Staudter.*

a well-respected brewer to help set up and manage the operation and began to build a reputation for wonderful beers. Brewer Allen Van Anda began by brewing the Golden Helles and then added the Vienna Amber and Dunkel Lager. Soon an assistant was needed, and Allen called his friend Jamie Griffith.

The Trapp Lager brands were an instant hit, and pretty soon the brewery was doing all it could to keep up. It added seasonal brews and pulled out all the stops each year for an Oktoberfest celebration that included a marzen aged to perfection. It wasn't long before the Von Trapps were publically talking about an expansion.

BACKACRE BEERMAKERS

March 2010

This brewery isn't really a brewery, but a blendery. The start date is also elusive because it was years before the first bottle of its Golden Sour Ale went on sale. While in a traditional sense the Backacre Beermakers left most people in the brewing community scratching their heads, it is continuing a very old tradition of making a specialized beer that is aged in barrels and then blended. The first beer it released was a blend of beers that were one, two and three years old and then bottle-conditioned. The result was a wonderfully tart beer that was perhaps one of the most exciting new creations to come from Vermont. For those who need to pin a style on this type of brew, it is called a gueuze.

The brewery is the brainchild of Erin Donovan, Matt Baumgart and John Donovan—a husband-and-wife team who became interested in sour Belgian styles and Erin's father, who runs the operation in Weston. The trio meets periodically to sample the aging beer and determine how to blend and bottle it. Erin and Matt had the opportunity to spend two years studying the sour beers of Belgium, and their backgrounds in the sciences have helped in creating this unique beer. The first bottles were released in 2012.

NORTHSHIRE BREWING

April 2010

There is nothing like winning an award at a homebrew competition to knock someone off the fence and into the world of professional brewing. This is what happened in 2009 to Chris Mayne and Earl McGoff after they won a people's choice award at a contest in Bennington sponsored in part by Madison Brewing. The two became friends while working together for an auto parts company and found they shared a love for good beer. Both became avid homebrewers with thoughts of opening a brewery some day. Then, they won the contest.

Chris and Earl knew they had a lot to learn about running a brewery, so they attended the Craft Brewers Conference in Boston, where they got the information they needed and found equipment. They set up the brewery

in some space next to the auto parts store, and while at first they both kept their day jobs, soon Chris and his wife, Karen, were working at the brewery all the time.

They purchased a seven-barrel brewhouse and some fourteen-barrel fermenters; then all they had to do was figure out how to scale up their recipes. They spent their first year perfecting Battenkill Ale and Equinox Pilsner, and occasionally they tried out new styles and recipes. Demand for Northshire Brewing's drafts took off with accounts as far away as Burlington, and they began to sell twenty-two-ounce bottles.

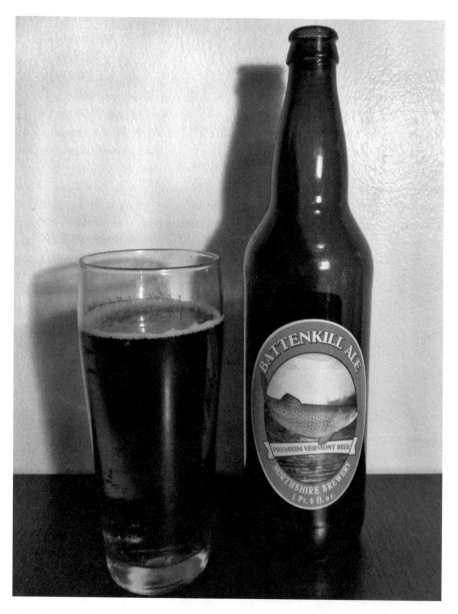

Above: Battenkill Ale, the flagship of the Northshire Brewery. *Photo by Adam Krakowski.*

Opposite: On a hot summer day, reach for an Equinox Pilsner. *Photo by Kurt Staudter.*

PERFECT PEAR CAFÉ/VERMONT BEER COMPANY
May 2010

The Perfect Pear Café in Bradford was one of those rare eateries that knew how to do beer pairings right. Chef/owner Adam Coulter had run a number of successful beer dinners, bringing to the restaurant some of the top names in the brewing community. He decided that he'd like to try his hand at brewing and purchased a Sabco system that would yield a little more than ten-gallon batches. After remodeling the bottom floor of the historic mill house and turning it into a tavern, the Vermont Beer Company was launched. While Adam was always interested in the brewing, there were a number of brewers who worked the brewhouse while Adam created some of the most elegant meals to be found at a common brewpub. There were always one or two house beers on tap, along with a number of guest craft beers. Adam also realized his dream of running a beer-pairing dinner that included his house beers. By September 2012, Adam had closed the business, realizing that no matter what he did, there wasn't enough business coming through the doors to keep it afloat.

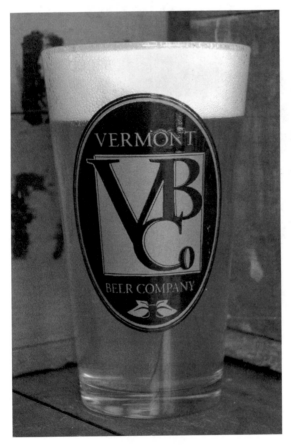

The Vermont Beer Company.
Photo by Kurt Staudter.

HILL FARMSTEAD BREWERY
May 2010

While there are many brewers who got their starts as homebrewers, Shaun Hill is perhaps the only one who started while he was still in high school. At fifteen years old, he became interested in yeast and the magic of fermentation, and as part of a school project, he brewed a batch of beer. He even presented a bottle of the brew to the teacher. The dark amber ale brewed with blackberries had chunks floating around in it and in all likelihood was less than perfect, but the kid had to start somewhere. Even after he left home for college, his passion for good beer continued, and after graduation, he was being less than truthful on his résumé in order to land a job, any job, in brewing.

Happening to stop into the Shed for a beer in 2002, he got hired by Tim Dahahy and Howie Faircloth to wash kegs and clean growlers. He worked at the brewery for a few months, quickly learning more and assuming greater responsibilities, but he left in order to travel. After returning home, he painted houses one last summer, and in January 2005, he heard about an opening at the Shed. He took the job as head brewer when the Shed was at its peak as a brewpub/production brewery and threw himself into the job. In addition to keeping up with the demand, Shaun began to get creative with one beer a week. After a while, he hired Jim Conroy as his assistant, and for the last year at the Shed, he was given a lot of freedom to be creative.

In 2006, he began to make plans to build his own brewery in Hardwick. He signed a hops contract for three years, left the Shed and took a job with Dan Gates at Trout River Brewing. His original plan was to start Grassroots Brewing in Hardwick and earn enough money to move it to the family farm. In 2007, he got a loan for $25,000 and had a setback when a deal for space fell through.

At this point, Shaun looked for a job in Europe and sent out letters to a number of breweries. In what became a transformative moment in his life, he got offered a job at the Copenhagen brewpub Norrebro Bryghus and worked with former Carlsberg production brewmaster Anders Kissmeyer. From March 2008 until November 2009, Shaun was mentored by Kissmeyer and began relationships with other European brewers through collaborations, and by the time he left, the beers that he was brewing were winning medals at the World Beer Cup. The experience changed Shaun, making him a better brewer while solidifying his process, and when he

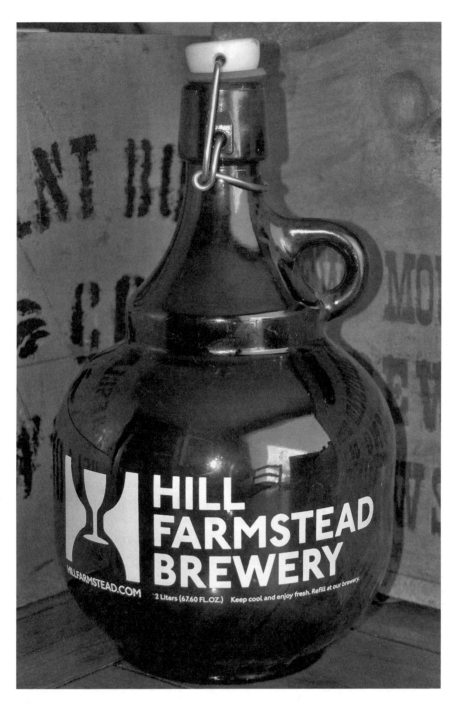

Not only are Shaun Hill's beers distinctive, but so are his growlers. *Photo by Kurt Staudter.*

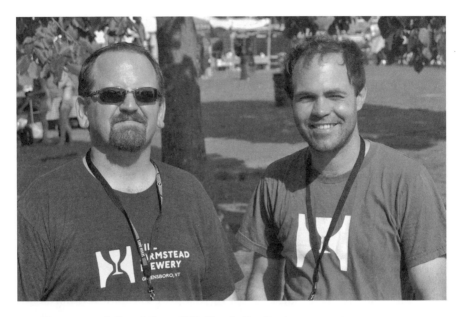

Bob Montgomery (left) and Shaun Hill. *Photo by Kurt Staudter.*

More Hill Farmstead beers. *Collection of Tucker Hayward, photo by Kurt Staudter.*

returned home with a business plan in hand, he was determined to build his brewery in Greensboro.

Having attracted European and American investors, Shaun and his brother Darren built the brewery from the ground up in an empty building on the family farm. The $80,000 in start-up capital and some equipment on loan or purchased from other breweries was all Shaun needed to put his plan into action. Working eighteen-hour days building the brewery, jumping through regulatory hoops and even scrutinizing every detail from logos to beer names (many named after the family who lived on the farm), Shaun and Darren did not stop until a dream that started in 2006 became a reality in 2010, when the first batch of Edward was brewed.

While this is a longer entry in the book than most of the others, it was important to point out that many of these brewers were not instant rock stars in the brewing world. Those who have become successful have often been at it for decades before they received the acclaim they deserved, and just as importantly, and perhaps more often, some really great hardworking brewers are never noticed. Shaun Hill paid his dues, and thanks to his uncanny marketing sense, solid business plan and dedication to the art of brewing, we all get to enjoy some of the best beers anywhere right here in Vermont.

It wasn't long before Shaun had the money to invest in an expansion, and in 2014, he and his brother are once again hard at work. While he expects the expansion with a brand-new German brewhouse will increase his output to between four and five thousand barrels, he still plans to self-distribute through his company, Grassroots Distributing.

13

2010–AUGUST 2011

THEN CAME IRENE!

At the beginning of 2010, Magic Hat's Mardi Gras celebration raised $100,000 for the Women's Rape Crisis Center. Rock Art was named the top trend-setting craft brewery of the year for 2009 by USA Beer Trends. By midyear, Rock Art announced that it would build a new brewery in Morrisville with completion predicted for the spring of 2011.

Long Trail purchased Otter Creek/Wolavers for an undisclosed amount of money. Because Otter Creek was in fifteen states and Long Trail in nine, this purchase opened up new markets for Long Trail. Also, because of the cap on wastewater discharges at the facility in Bridgewater, production at Long Trail was limited; by adding the Otter Creek brewery in Middlebury, Long Trail increased its production capabilities. The new company now has the ability to make over 100,000 barrels per year. Long Trail also announced a modernization initiative to spend over $1 million on a new lab; better kegging equipment, including new kegs; and energy efficiencies.

The Green Mountain Mashers renamed its homebrew competition the Annual Greg Noonan Memorial Homebrew Competition. The Vermont Pub & Brewery released a tribute beer for Greg named Tulach Leis, and it was just one of a number of tribute beers around the country brewed to honor Greg. Lawson's Finest won bronze at the World Beer Cup for his Maple Triple Ale, and later that year, at the Great American Beer Festival, the Alchemist brought home gold for its gluten-free Celia Pale Ale. Madison Brewing held the second homebrew competition to raise money for the Bennington Museum. Among the winners were Chris Maynes and Earl McGoff.

The Rock Art family greets you at the door of the new brewery. *Photo by Paul Kowalski.*

In the fall of 2010, the ink wasn't even dry yet on the Magic Hat/ Pyramid deal when the new company was acquired by North American Brewers, or NAB. Owned by KPS Capital Partners, NAB also owns the Genesee Brewing Company and the distributions rights to Labatt's and Seagram's coolers. The Brewers Association in Colorado removed Magic Hat from the list of craft brewers citing that it was no longer "independent." Founder Alan Newman left the leadership, along with other senior employees. Newly elected governor Peter Shumlin named Lawrence Miller secretary of the Vermont Agency of Commerce and Community Development.

Trapp increased its capacity by one-third adding a forty-five-barrel lager tank, giving the brewery the ability to lager a beer for six weeks or more. The Alchemist turned to Quebec stainless-steel specialist Yvon LaBonne for a new brew kettle. Patrick Dakin left as the second brewer at Jasper Murdock's in order to begin work on Freight House Brewing in Royalton. He was replaced by Jeremy Herbert, a former brewer from Golden Dome. Long Trail brewed Centennial Red Ale to celebrate Vermont's premier hiking corridor, the Long Trail. A portion of the proceeds went to the Green Mountain Club for trail maintenance. The Vermont Pub & Brewery began a small-batch program that showcased beers on Mondays.

Rock Art helps Pete's Greens. *Collection of Toby Garland, photo by Kurt Staudter.*

In 2011, Shaun Hill added a coolship tank to the Hill Farmstead Brewery and began to work on spontaneous fermentation and development of a strain of yeast unique to Greensboro. The brewery held its grand opening on Memorial Day weekend. Ray McNeill began brewing at his new production brewery by bringing back some of his classic recipes. Sean Lawson won the National IPA Championship by besting 127 other contenders with his Triple Play IPA. Jim Conroy began brewing five days a week at the Shed, increasing the distribution of the brewery's growlers. After a devastating fire at Pete's Greens, an important produce farm in the state, Rock Art helped raise $5,000 for reconstruction with its Pete's Greens Barn Raising Brown Ale, and on June 1, Pete's Greens was fully moved into its new ten-thousand-square-foot brewery. Northshire Brewing had achieved up to forty draft accounts in less than two years.

By spring, Jen and John Kimmich had begun construction on the new Alchemist Cannery. The facility would have a 15-barrel brewhouse and be capable of 1,500 barrels per year. They would brew two days per week and can four-packs of sixteen-ounce cans of Heady Topper, their double IPA.

TROPICAL STORM IRENE

On Sunday August 28, 2011, tropical storm Irene lashed the state with unprecedented rainfall, and flooding devastated thousands of homes and businesses. The Alchemist Pub & Brewery was destroyed when water filled the basement brewery and came waist deep on the dining room floor. Staff and volunteers turned out to help clean up in the aftermath, but a few months later, Jen and John announced that they would not reopen the pub. Four tanks of beer survived the flood. Tanks of El Jefe and Shut the Hell Up were unusable, but tanks of Heretic, a double IPA, and Luscious, an imperial stout, were saved with the help of Harpoon Brewery, Rock Art Brewery and Hill Farmstead Brewery. Luscious was bottled and sent to compete in the World Beer Cup, winning a silver medal. The Friday after the flood, the Kimmichs opened the new cannery.

Along with the unfortunate loss of this wonderful pub, the Long Trail Brewery was inundated when the Ottaquechee River jumped its banks. Long

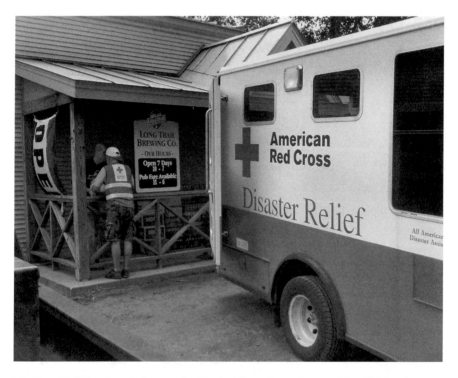

The Long Trail Brewing relief center after Tropical Storm Irene. *Courtesy of Long Trail Brewing*

Trail was cut off from the rest of the state because of washed out roads, but because of backup power, all the beer was untouched by the ravages of Irene. That backup generator was a godsend as the brewery became a beacon of hope for those stranded by the floods, offering a place for serving hot meals to survivors, first responders and then repair crews. Over two hundred meals were served.

Also trashed by flood waters were the former homes of the Windham Brewery/Flat Street Pub in Brattleboro and the Maple Leaf Malt & Brewing Company in Wilmington. Both buildings were completely flooded.

The Vermont brewing community was quick to step up with special beers and other fundraising efforts to help in the wake of Irene. Tens of thousands of dollars were raised for the relief efforts, and brewery staffs gave countless hours of volunteer time to their friends, neighbors and families. While the destruction was awful, seeing Vermonters come together to help one another was heartwarming. Long Trail brewed Good Night Irene, and Harpoon donated one dollar per case of beer it sold to relief efforts.

ALCHEMIST CANNERY

September 2011

As they were sifting through the debris at the pub in the wake of tropical storm Irene, Jennifer and John Kimmich had their attention divided. While they were devastated by the loss of the pub, the opening of their new fifteen-barrel brewhouse and cannery was less than a week away. The opening was the culmination of more than a year of work and the realization of their dream to have a production brewery.

The brewery was a beautiful state-of-the-art facility, and they took the bold step to can the beer. Lately, there are a number of craft breweries that are canning beer instead of bottling, and even some Vermont breweries have had their beers canned outside the state. But Jen and John were the first to do it here. Jim Conroy, formerly the head brewer at the Shed Restaurant & Brewery, was hired on as head brewer for the cannery and went to work with John at the pub for a training period.

Although John had a number of popular beers from the pub, he chose to brew just Heady Topper, his double IPA. The silver sixteen-

John Kimmich keeps an eye on the canning of Heady Topper. *Photo by Kurt Staudter.*

ounce can soon became one of the most sought-after beers in the country. People traveled hundreds of miles to stand in line to buy a few cases of this beer.

FIDDLEHEAD BREWING COMPANY

December 2011

Perhaps the most anticipated brewery opening in Vermont, the grand opening of Fiddlehead Brewing Company in Shelburne on New Year's Eve was something special. Matt Cohen had a humble beginning washing kegs and filling growlers at the Shed, but he eventually ended up spending six years as head brewer with Magic Hat and working there for a total of thirteen. During that time, he gained a reputation for his daring use of unorthodox ingredients. When the brewery was sold to North American Breweries, he was a member of the management team that would leave with Alan Newman.

Matty-O chills between sessions at the Vermont Brewers Festival. *Photo by Kurt Staudter.*

Fiddleheads aren't just for the springtime anymore. *Photo by Paul Kowalski.*

Matty Cohen returns to brewing after leaving Magic Hat with Fiddlehead IPA. *Photo by Kurt Staudter.*

Between the time when he left Magic Hat and when he opened Fiddlehead, Matt meticulously plotted out his new brewery. Every detail was carefully examined, and the business plan was developed. He built a fifteen-barrel brewhouse that was designed to his exacting specifications so that, if needed, it could be run by one person. It is this attention to every detail that made Matt such a success at Magic Hat and why everyone was excited to see what he would do next. It was worth the wait.

Fiddlehead IPA was the first beer the brewery released, and Matt knew enough to let the brand become established in the marketplace before offering other beers. In his plan, he expected to ship 500 barrels of beer in the first year, but he instead sent out 1,600. While his dream was to make 6,000 barrels per year, he paced himself and expected to produce 3,500 in 2013.

The brewery is located next to a BYOB pizza shop and always has a number of other beers besides its flagship. The beers sold and sampled at the brewery are Matt's opportunity to experiment with ingredients and styles. In something that he picked up while working at Magic Hat, Matty-O has a rebellious flair when it comes to the strict adherence to a style. While his beers are the height of the brewer's art and expertly crafted, they tend to stay just to the outside of the guidelines that win medals. It's not that he can't brew inside the box; it's just more fun to color outside the lines.

Drop In Brewing Company

May 2012

Out of all the breweries that ever started in the state, this one has perhaps the most interesting pedigree. It was the lifelong dream of Steve Parkes and his wife, Christine McKeever-Parkes, to open a brewery, and unlike many of the homebrewers who start breweries, Steve Parkes came at ownership from formal training—that much had been done before. However, the Drop In Brewery in Middlebury was built partly to serve as a teaching brewery and expanded classroom space for the American Brewers Guild. When it isn't helping students hone their skills, it serves as a playground for Steve to flex his creativity.

Steve Parkes is a bit of a legend in the brewing world. He was trained in Edinburgh, Scotland, at Heriot-Watt University, started the first microbrewery in Maryland when he opened the British Brewing Company in a Baltimore suburb, helped expand the Humboldt Brewing Company in

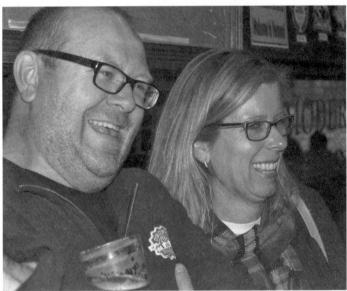

Top: Christine McKeever-Parkes pours a beer for a visitor at Drop In Brewing. *Courtesy of Steve Parkes.*

Left: Steve Parkes and Christine McKeever-Parkes. *Photo by Kurt Staudter.*

California and, all along the way, won some of the most prestigious awards for his beers. As if that weren't enough, in 1997, he took a teaching position at the American Brewers Guild and helped develop its online programs. In 1999, the owners decide to sell the school, and Steve bought it. Around the same time, Steve had taken a job with Wolaver's Organic to oversee quality control at the regional breweries that made its beer.

When Lawrence Miller sold Otter Creek to the Wolavers in 2003, Steve Parkes was brought to Vermont to oversee brewing operations. When Steve and Christine came to the state, they brought the American Brewers Guild as well. By 2008, the school had grown to the point that classes were selling out a year in advance, and the operations at Otter Creek were becoming more time consuming. Steve left the brewery to devote all of his attention to the school. Because of the number of students he helped to make better brewers and his contributions to the craft brewing excellence, in 2009 he was awarded the Russell Schehrer Award for Innovation in Craft Brewing by the National Brewers Association. The only other Vermonter to be honored with this award, considered being inducted into the "Brewers Hall of Fame," is Greg Noonan.

Operating the school in Salisbury and sending the students for internships at area breweries presented its own challenges as the number of students increased, and the breweries that would host

The beers at Drop In are often made with the help of the students from the American Brewers Guild. *Photo by Kurt Staudter.*

the students weren't capable of offering the hands-on experience that acted as a necessary capstone to the school. A location was needed that would solve these problems. The facility in Middlebury includes a brand-new fifteen-barrel brewery with four fermenters and well-designed classrooms with lab space. In addition to the highly sought-after brewing science classes, the ABG also offers other classes that appeal to the beer enthusiast.

14ᵀᴴ STAR BREWING COMPANY

June 2012

What happens when a homebrewer in the army gets deployed to Afghanistan and is given hours of boredom punctuated by moments of sheer terror? He and his buddy develop a business plan to build a brewery back home, of course. This is what happened when Steve Gagner and Matt Kehaya had some free time during their deployment in the desert. Steve

had become an avid homebrewer before leaving Vermont and had worked out a number of recipes that he was beginning to perfect. In one of those "if we ever get home from here" moments, they began to research drinking trends in Franklin County and what hoops one had to jump through to open a brewery.

After returning home, they looked for a space in St. Albans to build the brewery and settled on a storefront next to a transmission shop. The brewery is a combination of former maple sugaring equipment and cobbled-

Growlers from 14ᵗʰ Star were how many first tasted its beer. *Photo by Kurt Staudter.*

together brewing equipment. Named after the fact that Vermont was the fourteenth state, the brewery logo is a single star at the center of the original United States flag. They also billed themselves as the only "combat veteran owned brewery in Vermont." Considering that from the beginning they were brewing about thirty barrels a month in this tiny space, they are quick to attribute their success to help they received from other Vermont brewers that included everything from advice to loaned equipment. After some well-received limited release bottles of their flagship beer Valor, they soon hired Dan Sartwell, who had worked at a number of other breweries. It didn't take long for there to be an expansion announcement.

Foley Brothers Brewing

June 2012

Brothers Patrick and Daniel Foley had been working with their parents at the Neshobe River Winery in Brandon when they decided that it was time to branch out. Along with their sister Christine, they started out small, brewing on little more than a homebrew system in between their responsibilities at the winery. Their first beers were Ginger Wheat and Brown Ale, but it wasn't long before they introduced other beers.

Dan Foley relaxes between brews. *Photo by Christine Foley.*

Before they had been in business for a year, they were already planning an expansion. Not only were they bottling beers, but they had also secured a number of accounts for draft around the state. Foley Brothers was the first brewery to open up in Rutland County. The brewery is set up in an outbuilding that is surrounded by the grape vines of the winery. The tasting room is shared by the winery.

COVERED BRIDGE BREWING

June 2012

Curt Cuccia is another homebrewer who had a dream of owning a brewery, and he also is following the time-honored tradition for you don't have the capital to actually build one—contracting the brew. While he does still operate a small half-barrel system at his Lyndonville tasting room and will fill growlers, his flagship beer, Lucky Me, is being made in Holyoke, Massachusetts, at Paper City Brewing.

Plans to eventually build a brewery or having the beers brewed in Vermont are both things that Curt has talked about in the past.

GRATEFUL HANDS BREWING

August 2012

Grateful Hands Brewing probably isn't the smallest brewery that ever started in Vermont, but it is very close. Ricky and Joy McLain started brewing beer a few years earlier as homebrewers when they decided that they would go pro. The brewery in Cabot is in a section of their house in what used to be a garage. Being an engineer by training, Ricky has made many of the improvements to the space to accommodate the brewery.

In the Vermont nanobrewery tradition, each batch of beer is less than twenty gallons. Ricky tends to focus on the darker styles of beer, and the beers were for sale by growler at the brewery. They shut down operations by the spring of 2014.

Grateful Hands Brewing brings beer to Cabot from Ricky McLain's garage twenty gallons at a time. *Photo by Kurt Staudter.*

Kingdom Brewing

September 2012

Billed as the most northern brewery in the state, Jenn and Brian Cook started brewing at home in Newport. In that time-honored story of being encouraged by friends and family, they decided that they would seek out a federal brewer's notice and a Vermont license to manufacture. Brewing on their farm with a 4.5-barrel system, they now have visitors feeding spent grains to their livestock. Packaging most of their beer in kegs for local bars and restaurants, they also bottle some of their beers and sell growlers.

One of their brands caused quite the stir with the name Skinny Bitch, which quickly became popular as a wonderful, easy-drinking session beer. They also produce Out-of-Bounds IPA, Clyde River Brown, Round Barn Red, The 19th Hole and Bear Mountain Blackberry Chocolate Milk Stout.

Left: Although mostly draft only, occasionally Kingdom Brewing does bottles. *Photo by Kurt Staudter.*

Opposite: Jenn and Brian Cook of Kingdom Brewing. *Photo by Kurt Staudter.*

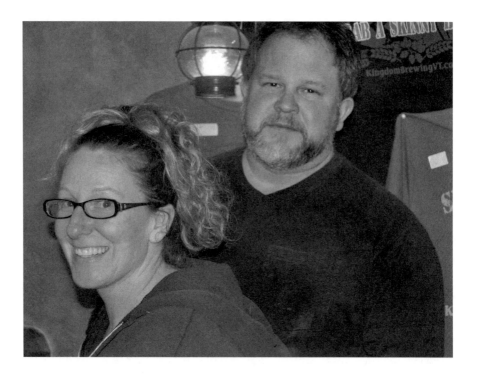

Brian was the one that started with the homebrewing, but it is Jenn that has found her calling as a brewer. Together they are building quite the name for their brewery in a part of the state that is seeing development because of new investment in Jay Peak and other area businesses.

THE CROP BISTRO & BREWERY

January 2013

After Ken and Kathy Strong closed the Shed Restaurant & Brewery and the brand sold to Otter Creek, along with the brewing equipment, the Crop Bistro & Brewery moved into the space on Mountain Road in Stowe. The brainchild of partners Steve Schimoler and Tom Bivins, the Crop was going to keep the welcoming feel of the Shed while bringing a slightly upscale menu. For a while, it operated as just a restaurant with Mark Ewald being announced as the first brewer. However, before the beautiful 8.5-barrel

copper-clad brewhouse arrived from Bravaria, longtime brewer Will Gilson, formerly of Moat Mountain in New Hampshire, ended up with the head brewer job.

Will has had a fascination with German-style beers since he spent time there in college, and he especially likes weiss beers. But he plans on putting the new brewery through its paces brewing ales along with the lagers and wheat beers.

PROHIBITION PIG

January 2013

Chad Rich had been a well-respected figure in the Burlington beer scene with time spent at American Flatbread/Zero Gravity Craft Brewery and the Farmhouse Tap & Grill, but he had a dream of having a place he could call his own. After the flood of Irene took out the Alchemist Pub & Brewery in Waterbury and the Kimmiches announced they wouldn't be reopening the pub, they helped Chad open the Prohibition Pig in the old Alchemist space. He hired back almost all the folks who lost their jobs with the closing of the Alchemist.

Given his years in the restaurant business, there was no doubt that Chad would create a place that offered good food with an excellent beer list. There also always was the expectation that beer would be brewed there again. To that end, Chad began to develop a house beer with brewer Nate Johnson, and they had it contract brewed at the Rock Art Brewery in Morrisville. The Prohibition Pig Pale Ale had its own strain of yeast and became an instant hit. Because of Chad's connections with the brewing community, he next worked with Brian Strumke of Stillwater Artisanal Ales in Maryland on a collaboration beer.

In December, Prohibition Pig received its federal brewer's notice and purchased the original one-barrel system that propelled Sean Lawson to fame. This system will be used to make the house beers and be located in the same basement that flooded in the Alchemist, but this is just a stopgap measure as the building next door is renovated for a larger and less vulnerable brewery.

BREWSTER RIVER PUB & BREWERY
April 2013

Billy and Heather Mossinghoff have over forty years of experience in the bar and restaurant business. Add to that Billy's obsession with homebrewing, and you just knew that, once they bought the Jeffersonville pub, it was only a matter of time before some of the taps would pour their own beer. After getting all the proper licenses, Billy started putting his new half-barrel system through the paces. Within a few months, he'd brewed over thirty batches of beer, never having duplicated any of the recipes. While he does expect to eventually settle on a few flagship beers and has a preference for IPAs, he is still having too much fun with his new brewery.

In addition to a great selection of not only his beers but also other Vermont brews, the menu at the pub offers comfort food and pub fare, along with some upscale choices.

LOST NATION BREWERY

May 2013

Allen Van Anda and Jamie Griffith got to know each other working at Vermont Soy in Hardwick. It's hard to say if making tofu prepared them for the careers in brewing they've carved for themselves, but it probably has more to do with the years they spent brewing together at the Trapp Lager Brewery or the time Allen spent cutting his teeth at Kross Brewing.

Then there is the positive magic of their location in Morrisville. They moved into the space vacated by Rock Art Brewery after it built its new facility elsewhere in town. Raising just under one million dollars through a bank loan and investors, Allen and Jamie practically had beer sold before it was even brewed. They had such a wonderful reputation from the work they'd done with the Von Trapp that their beer was almost as eagerly awaited as the first release from Fiddlehead.

The Canadian-built brewhouse is capable of 8,000 barrels per year, and they were on a pace to finish its first year at around 3,500 barrels. As every brewery looks for that one thing that sets it apart, Lost Nation has hit on something somewhat unique.

Sean Lawson (left) and Allen Van Anda. *Photo by Kurt Staudter.*

While other brewers strive for more hops or higher alcohol, the philosophy at Lost Nation is to brew beers with lower alcohol that just burst with flavor. One of the first beers brewed was an ancient German style called a gose that had all but been forgotten. This is a slightly salty beer that just explodes in your mouth with flavor. All the brewery's beers can be considered session beers—beers that one can drink with friends for hours without getting too sloppy.

Although it wasn't really part of the original plan, Lost Nation has created quite the reputation for its food in the tasting room. Chef Erik Larson with the help of Joey Nagy created an ever-changing menu that makes use of local ingredients and tends to be upscale with down-to-earth prices.

Whetstone Station Restaurant & Brewery

May 2013

Tim and Amy Brady came to Vermont and bought a bed-and-breakfast in Brattleboro, but they still had a hand in consulting other hospitality businesses around the country. David Hiler had also been in the restaurant and hospitality business, where he was spending more time than he wanted away from his family. It was over a few beers that the Bradys and Hiler decided that they would purchase the vacant Riverview Café and turn it into a brewpub.

Tim and Amy had made names for themselves in the Vermont brewing community, first for their web-based beer program called "Here for the Beer," for which they interviewed a number of brewers, and then for spearheading the first Brattleboro Brewers Festival in 2011. Even at their bed-and-breakfast, they had a bar where they always had something delicious on tap, and you knew even then they'd own a brewery one day.

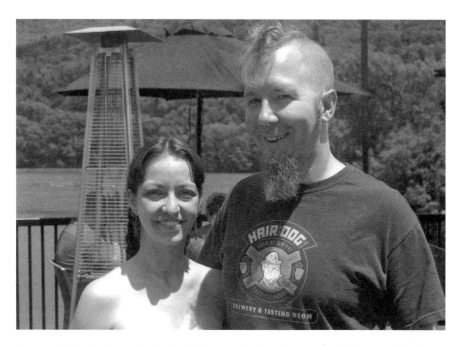

Amy and Tim Brady on the deck at Whetstone Station Restaurant & Brewery. *Photo by Kurt Staudter.*

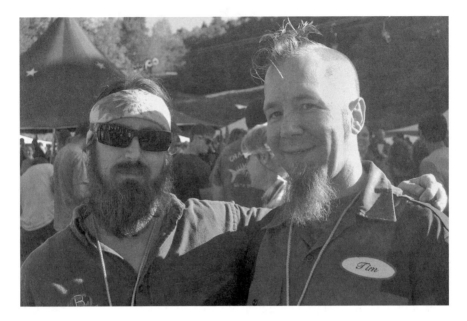

Mike Gerhart (left) and Tim Brady. *Photo by Kurt Staudter.*

While waiting on the 3.5-barrel brewhouse from Aztec Brewing in California, they opened the restaurant and quickly established themselves as a top-rated beer bar with fifteen different beers on tap and an extensive bottle list. When the brewery began to operate, they started to devote a single tap to their house beers with hopes of including more as time went on.

BLACK LANTERN BREWPUB

June 2013

At the Black Lantern Inn in Montgomery, there has always been a wonderful little Irish pub, and in June, it decided to get into brewing its own house beers. Not much is said about the beers on the pub's website, and given how close it is to Jay Peak during the winter, a small system might get overwhelmed by the demand.

Stone Corral Brewing
August 2013

Bret Hamilton got into homebrewing in 1991, and while his day job put food on the table, it was his passion for brewing that led him to eventually go pro. The Huntington nanobrewery is in a beautiful location in the shadow of Camels Hump, and he started out with brewing twenty-gallon batches of three beers simply named Black Beer, Dark Wheat Beer and Beer. Bret wants his to be the community brewery and is selling different levels of memberships that entitle folks to pick up beer each month at the brewery. This is kind of like a CSA (community supported agriculture) only much better—it's for beer. Response from the community led him to invest in a brewery upgrade before he'd been brewing for even a year.

1ˢᵀ Republic Brewing

February 2014

In a story that sounds somewhat familiar in Franklin County, Kevin Jarvis and Shawn Trout are army buddies that both enjoyed good beer. They set up their nanobrewery in Kevin's garage in Fairfax with dreams of taking it to the next level. Their first beer is an American pale ale that they are distributing in kegs.

Infinity Brewing

February 2014

Located in South Burlington, this brewery is a partnership of two longtime homebrewers who had that recurring dream to own a brewery. Both are successful, one as an electrical contractor and the other working with one of the largest employers in the state, but partners Glenn Cummings and Murray Seaman are determined to make a go at the brewing business. In a building that is shared with the electrical business owned by Cummings, a

beautiful seven-barrel Portland Kettle Works system is in use, and an inviting bar is part of their tasting room.

They promise high-quality beers available at the brewery in growlers and twenty-two-ounce bottles. The first beers they made were an IPA, an Irish red ale and a Belgian saison. The slogan for the brewery is "Vermont Craft Beer without Limits."

FOUR QUARTERS BREWING

March 2014

Brian Eckert spent fourteen years homebrewing before he took the plunge into the professional brewing world. He picked a spot just a short way from the downtown circle of Winooski to be near growing music and food scenes and set to work on his production brewery. The four-barrel brewhouse won't be dedicated to particular style, although the first beers he presented to the public were Belgians. His interests also extend to IPAs, and he hopes to get into some barrel aging.

BURLINGTON BEER COMPANY

April 2014

It can be said that Joe Lemnah got his start as a homebrewer, but he didn't stay one for long. Almost right away, he began a professional brewing career that had him brewing at Olde Saratoga Brewing Co., Dogfish Head Craft Brewing Co. and Evolution Craft Brewing Co. He also went through the American Brewers Guild. Since Joe grew up in Vermont, it was his dream to return home to open a brewery. Along with his longtime friend and partner Jake Durell, he meticulously planned a new brewery in Williston.

With an emphasis on unique blends and locally sourced ingredients, Joe and Jake set a 700-barrel production target in the first year with projections of over 6,500 barrels within the first few years. Joe is going to start a barrel-aging program soon and plans to have bottled-conditioned beers in addition to draft accounts.

QUEEN CITY BREWING
May 2014

While this Burlington brewery is another start-up by homebrewers, it represents a significant investment. The brewhouse is a fifteen-barrel, four-vessel system, with six fifteen-barrel fermenters and two fifteen-barrel bright tanks. Queen City's plan is to brew and distribute one thousand barrels in its first year as draft only and be making as much a three thousand barrels per year by the third year. Partners Paul Hale, Paul Held, Phil Kaszuba and Maarten van Ryckevorel have brought enough capital to do this right, and it shows. Their tasting room includes a beautiful mahogany bar that used to be in the now closed Ethan Allen Club, and they will also sell you a growler to go. As homebrewers, they have won awards for many different styles, and many of their beers have been brewed by the Vermont Pub & Brewery in conjunction with the Green Mountain Mashers.

SIMPLE ROOTS BREWING

May 2014

Dan Ukolowicz and Kara Pawlusiak are a husband-and-wife team with good day jobs in public schools, but that didn't stop them from taking their passion for good beer to the next level. A homebrewer for the last fifteen years, Dan got one of the coveted slots at the American Brewers Guild and did an internship with Paul Sayler and Destiny Saxon at the Zero Gravity Brewery in the summer of 2013.

Located in a converted garage in the New North End of Burlington, they've put together a three-barrel brewhouse with a fermenter and a bright tank. They plan to distribute locally to a few establishments that focus on good food and beer.

2011—PRESENT

VERMONT IS THE WONDERLAND OF BEER

In October 2011, the iconic Shed Restaurant & Brewery was forced to close after being unable to come to terms with its landlord. After almost thirty years, a devastating fire and seventeen more years operating a brewery, Ken and Kathleen Strong found one obstacle that they could not overcome. While they scrambled to find a new location to reopen the Shed, Otter Creek Brewing made them an offer to purchase the brewery and the Shed's brands. The landlord would announce that a new restaurant and brewery was going to reopen the property.

The Perfect Pear Café/Vermont Beer Company lost its chef and owner Adam Couture, who went back into the kitchen. Brewing was picked up by Chris Perry and a number of guest brewers, including Patrick Dakin formerly of Jasper Murdock's and Tucker Hayward.

Russ FitzPatrick of Vermont Pub & Brewery worked with Dr. Heather Darby of the University of Vermont extension to brew experimental batches of beer with 100 percent Vermont hops and barley. Other brewers, including Mark Magiera from the Bobcat Café and Mike Gerhart of Otter Creek, work with UVM toward revitalizing the once thriving hops cultivation in Vermont.

After leaving Magic Hat, Alan Newman and Stacey Steinmetz started Alchemy & Science as an independently operating subsidiary of the Boston Beer Company, the brewers of Sam Adams. After a meeting with owner Jim Koch, Alan and Stacey opened an office in Burlington to work on expanding the vision and reach of craft brewing into the future. In early 2012, they

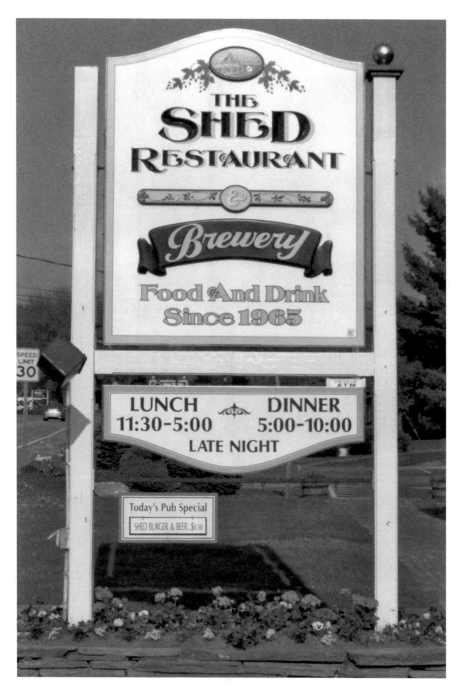

Shed Burger and beer for $8.50—what could be more Vermont? *Courtesy of Vermont Brewers Association.*

purchased the Angel City Brewpub. The pub, which was established in 1997, was in the middle of moving into downtown Los Angeles, and the new company looked to use it as a test platform for innovation.

Otter Creek found huge demand for the Shed Mountain Ale and Shed IPA, distributing it throughout its distribution network in New England. Rock Art began distributing in Maine, Massachusetts, New Jersey and

Above: Ray McNeill—and he cooks too! *Photo by Paul Kowalski.*

Opposite: The Shed lives on in beer. *Photo by Adam Krakowski.*

Pennsylvania. McNeill's began to package some of its stronger beers like Troll Black Beer, The Exterminator Doppelbock and pub favorite Old Ringworm. Sean Lawson promoted his nanobrewery at farmers' markets. This unique marketing created a huge demand and was a big draw at the markets he attended. Jasper Murdock's held a yearly "Beer & Poetry Night" in conjunction with Delores "Do" Roberts of *Bloodroot* literary magazine. The Vermont Pub & Brewery purchased Amelia, a half-barrel pilot brewery and announce that on Mondays it would showcase the experimental brews. Allen Van Anda left the Trapp Lager Brewery in order to plan his brewery and spend some quality time with his young family. He was replaced by J.P. Williams, formerly the head brewer from Magic Hat.

Ray McNeill and collector/amateur historian Toby Garland teamed up to hold "McNeill's Antique Beeriana Beer Show." The event brought beer memorabilia collectors out to the packaging brewery. At the 2012 World

Above: Allen Van Anda (left), Paul Sayler (center) and Scott Kerner (right) of the Three Penny Taproom in Montpelier. *Photo by Kurt Staudter.*

Left: After years of refusing to sell growlers, finally Long Trail relented. *Photo by Kurt Staudter.*

Beer Cup, Lawson's Finest Liquids and the Alchemist won silver medals. Long Trail held a fundraiser for Vermont Adaptive Ski & Sports to help promote outdoor recreation for the handicapped community. The Bobcat Café brewed and bottled a benefit beer called Flood Suds to help farmers whose lands were ravaged by Irene, and Long Trail brewed Good Night Irene for a second year. Madison's held the sixth-annual Southern Vermont Homebrew Competition to raise money for the Bennington Museum.

The twenty-year anniversary of the Vermont Brewers Festival brought out a number of collaboration beers. Quebec brewers Andre Trundel of Le Trou du Diable, Benoit Mercier of Benelux Brasserie, Fred Cormier of Hopfenstark and Luc (Bim) Lafontaine and Jean François Gravel of Dieu du Ciel, all work with Vermont brewers to create unique beers for the event.

By the end of 2012, Waterbury had been named the "Beer Town in New England" by the *Boston Globe*, and Switchback celebrated its tenth anniversary by introducing its new state-of-the-art bottling line. The Alchemist added tanks, doubling its production. After seventeen years, Glenn Walter closed the College Street location of Three Needs Taproom & Brewery and reopened it on Pearl Street. Although there were plans to reopen as a brewery, the old brewery was sold to Bill Metzger of Brewing News to be part of his pub in Buffalo, New York. As of 2014, other renovation projects are taking precedence over revitalizing the brewery.

In 2013, it was announced that after six years at the helm, Long Trail CEO Brian Walsh would leave the company. Under Walsh's leadership, Long Trail expanded production, purchased Otter Creek, Wolaver's and the Shed and became one of the leaders in the craft beer movement. Shortly after his departure, it is announced that he will take over the leadership of the iconic Pittsburg Iron City Brewery.

Alchemy & Science launched the Traveler Beer Company and introduced a wider audience to the shandy beer style. In some European countries, a popular summer drink is to mix beer and some sort of juice. Time Traveler, Tenacious Traveler and Curious Traveler have become popular session beers. Soon after, the company announced the Just Beer project and then purchased Schmaltz Brewing and the Coney Island and He'brew beer brands.

At the annual hops conference held by the UVM extension, the Vermont Brewers Association presented a check to Dr. Heather Darby for $20,000 to purchase an ultraviolet spectrophotometer to aid in hops research. The grant enabled researchers to accurately analyze various attributes of Vermont hops without having to send samples away to a lab.

In June, the Trapp Lager Brewery broke ground on a big expansion. The new brewery produced up to fifty thousand barrels per year. J.P. Williams brought his experience and background running the largest brewery in the state to the expansion project. Much of the money raised for the project came from foreign investors who took advantage of a program that entitles them to visas in exchange for their investment.

Paul Kowalski, the longtime Vermont correspondent for the *Yankee Brew News*, left in order to plan a brewery. He was replaced by Kurt Staudter, one of the coauthors of this book, and hopefully by both in the near future. Since 2002, Harpoon has raised $560,000 for the Vermont Food Bank. William Gardner took over brewing at Madison's, and Switchback bottled its Slow-Fermented Brown Ale.

After a devastating illness that nearly took his life, Ray McNeill was unable to run his twenty-barrel packaging brewery. While staff, including Doug Locke, Orion Staudter and Ryan Harrington, did their best to keep the facility running, his absence proved to be a fatal blow to the business. By the end of 2013, the facility was for sale. Up in the Northeast Kingdom, after seventeen years of running Trout River Brewing, Dan Gates announced that he was looking for a buyer for the brewery. On a positive note, Long Trail outfitted the original farmhouse on its campus with a pilot brewery. Test batches of beer were cycled through the visitors' center for comment, and those that receive a favorable response were put into production. The first of the "Farmhouse" beers were a twelve-pack of IPAs in unique packaging.

The demand for Heady Topper was so great that, during the Columbus Day weekend, traffic from the brewery was blamed for gridlock in Waterbury. The Alchemist announced that they would cease selling the beer from the brewery and hope to come to an agreement with the town soon. Eventually it announced a second brewery would be built to accommodate its retail traffic and in order to expand production into other Alchemist brands.

The Vermont Pub & Brewery celebrated twenty-five years with ongoing special events culminating in a plaque to honor Greg Noonan unveiled at the brewery. The crowd of around eighty stood at the dedication and listened to heartfelt tributes from friends and fellow brewers. After the ceremony Steve Polewacyk invited everyone to enjoy special beers brewed for the occasion. In attendance was the entire Vermont brewing community, and as you walked around the pub, most of the conversations were focused on just how far the Vermont brewing scene has come in such a short period of time.

In 2013, there were over 1,060 redemptions of passports from the Vermont Brewery Challenge. The Vermont Brewers Association reports

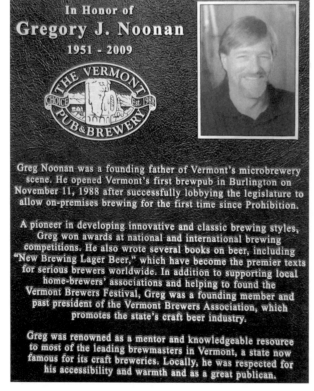

Above: Dave Hartmann with the Farmhouse Pilot Brewery. *Photo by Kurt Staudter.*

Left: A bronze plaque honors Greg Noonan at the Vermont Pub & Brewery in Burlington. *Photo by Kurt Staudter.*

171

that three-quarters of the passports returned for prizes came from out-of-state participants.

The Switchback owners were named the 2014 Vermont Small Business Persons of the Year by the U.S. Small Business Administration. Bill Cherry and Jeff Neiblum were singled out for the highest honor offered by the SBA for their contribution to the economy.

EPILOGUE

The finishing touches on this book coincided with the 2014 Craft Brewers Conference in Denver, Colorado. During the flight out, there were other brewers traveling to this annual gathering of the craft brewing community, and conversations about beer could be heard all over the plane. While I was talking to someone in the seat next to me, a head popped up over the seat in front of us. It belonged to Marty Bonneau, who announced that he's starting a new brewery in Vermont. Marty and his partner, Chris Capetz, are planning to open a brewery in Williston called Good Water Brewing. He explained that his last name, Bonneau, means "good water." A longtime homebrewer with a good job and a career, he follows a long line of folks willing to chuck it all to do what they love best.

Here in Vermont, new breweries are popping up so fast that it is impossible to keep track of them all, but here are a few that have been talked about as we put this book to bed: Mike Czok in Braintree plans to brew on a half-barrel system at the Bent Hill Brewery; Partners Carol Hall, Josh Hoehl and Ben Lineham will restore Tunbridge to the brewing map with Brocklebank Craft Brewing; Charlie Menard and Andrew Davis are close to opening Canteen Brewing Company, a seven-barrel brewery, and Localfolk Smokehouse will brew Cousins Brewing beers with a two-barrel system, both in Waitsfield; Roaring Brook Brewing in Killington is having its beers contract brewed by Rock Art; and the Burlington Coop Brewpub is looking to do for brewpubs what CSAs have done for farmers.

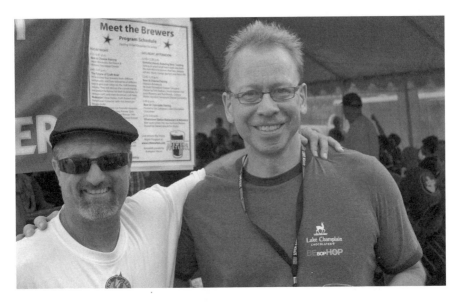

Dave Hartmann (right) with the owner of Roaring Brook Brewing at the Vermont Brewers Festival. *Photo by Kurt Staudter.*

It's not just a catchy slogan; it's a lifestyle choice. *Photo by Kurt Staudter.*

As if that weren't enough, J'ville Brewery will be a side project of the Honora Winery & Vineyard in Jacksonville. The Knotty Shamrock in Northfield will have its own beers on tap for Friday nights, and West Mountain Brewing Co. will offer its beers exclusively at the Rattlesnake Café in Bennington. Another couple of breweries in planning are the Barton River Brewery in the Northeast Kingdom town of Barton and the Frost Beer Works in Hinesburg. The Hop'n Moose Brewing Company will go where no brewpub has gone before and open in an old furniture store in downtown

Rutland. Former UVM hockey player and homebrewer Dale Paterson feels that it is high time that Rutland has a brewpub, and so far, others agree. Then there are the ongoing projects by Patrick Dakin and Paul Kowalski, and given the years of experience that these guys have, you just know that it will be worth the wait.

Will all of these breweries flourish? That depends on a few things. There is no way that the Vermont market has reached the saturation point. There is plenty of room for small-town breweries that focus on their little corner of the state, and Vermonters have no end to their capacity to embrace local businesses. However, like any business endeavor, if it is to be successful it has to sell a product that people want, and its owners have to have the skills to run their business. Looking at the history of Vermont beer it is clear that you have to have both of these things in order to be successful. There were plenty of great brewers like Steve Mason, Bennett Dawson, Kip Ross, Russ FitzPatrick and Liz Trott who all made fantastic beer but, for one reason or another, just didn't make it in the business with their own breweries.

Then there are the small breweries that never had enough capital or, in one example, tried to run an operation without electricity that were doomed from the start. Other short-lived breweries just made crappy beer, and there's this funny thing called the marketplace that has a way of dealing with that sort of problem quite quickly.

Vermont has proven to be fertile ground for the craft brewing movement; however, moving forward, there might be some challenges. While the growth now seems limitless and the willingness of Vermonters to support their small breweries is unquestionable, the stagnant population growth in the state and an aging demographic may constrain further growth. Also, so many of the new breweries built on shoestring budgets are entering a crowded marketplace and are being forced to compete with well-capitalized and mature breweries that got away with the mistakes that are a game ender for a start-up today.

It looks like by the end of 2014, Vermont will have over forty operating breweries from half-barrel nanos to some of the largest craft breweries in the country. Will all these breweries last? Probably not, but as long as Vermonters continue to homebrew there will always be that brewer who dreams of going pro. And here in Vermont, there will always be that friend or neighbor who will encourage you to make the jump. Cheers!

NOTES

PREFACE

1. *Burlington Weekly Free Press*, May 11, 1877, 2.

BANTER

2. *Washingtonian*, August 20, 1810, 4.

CHAPTER 1

3. Peter Onuf, "State-Making in Revolutionary America: Independent Vermont as a Case Study," *Journal of American History* 67, no. 4 (March 1981): 815.
4. *Vermont Journal and the Universal Advertiser*, August 31, 1790, 3.
5. Ibid., February 23, 1790, 3.
6. Ibid., January 5, 1789, 3.
7. Zadock Thompson, *History of the State of Vermont: For the Use of Families and Schools* (Burlington, VT: Smith and Company, 1858), 246.
8. *Morning Ray*, January 17, 1792, 4.
9. *Spooner's Vermont Journal*, May 20, 1796, 4.
10. *Vermont Journal and the Universal Advertiser*, April 19, 1791, 4.
11. *Vermont Gazette*, February 22, 1793, 4.

12. Samuel Swift, *History of the Town of Middlebury: In the Country of Addison, Vermont* (Middelbury, VT: A.H. Copeland 1859), 241.

13. Vermont Historical Society, Jabez Roger Broadside, 1794, VHS B, Side D, 658.1712.m58.

14. Longman, et al. "The Edinburgh Gazetteer, Or Geographical Dictionary," vol. 6 (Edinburgh, 1822), 493.

15. *Spooner's Vermont Journal*, December 2, 1793, 4.

16. *Rutland Herald*, April 3, 1797, 4.

17. John C. Wriston, *Vermont Inns and Taverns: Pre-Revolution to 1925* (Rutland, VT: Academy Books, 1991), 462.

18. Vermont Historical Society, Knapp Tavern Daybook 1818–49, XMSC 28:19, Manuscript Vault.

19. John Hull Brown, *Early American Beverages* (Rutland, VT: C.E. Tuttle, 1966), 98.

20. *Federal Galaxy*, "Directions for Making Ale and Strong Beer," December 12, 1797, 4.

21. Ernest Bogart, *Peacham, the Story of a Vermont Hill Town* (Washington D.C.: Univeristy Press of America, 1981), 267.

22. *Green Mountain Patriot*, December 9, 1801, 1.

23. Bogart, *Peacham*, 267.

24. Hamilton Child, *Gazetteer and Business Directory of Chittenden County, Vermont for 1882–83*, (Syracuse, NY: Hamilton Child, 1882), 113.

25. Ibid.

26. *Vermont Centinel*, April 5, 1805, 3.

27. *Burlington Free Press*. March 14, 1831.

28. Howard S. Russell, *Long Deep Furrow: Three Centuries of Farming in New England* (Hanover, NH: University Press of New England, abridged 1982 by Mark Lapping), 139.

29. *Rutland Herald*, March 6, 1816, 4.

30. *Federal Galaxy*, July 19, 1802, 3.

31. *Rutland Herald*, June 10, 1818.

32. Dawn D. Hance, *History of Rutland, Vermont, 1761–1861* (Rutland, VT: Rutland Historical Society, 1991), 332.

33. *Spooner's Vermont Journal*, March 26, 1821, 3.

34. While the Hickoks created the original Burlington Brewery in 1828, different sources have attributed the creation of the Burlington Brewery to William Savery Warder. William Savery Warder (1791–1831) was a Philadelphia Quaker whose account book for a "Burlington Brewery" is housed in the Jones-Cadbury Family Papers, circa 1770–1994, in the

Haverford College Library. The location of Warder's Burlington Brewery was most likely located in Burlington, New Jersey, close to Philadelphia, Pennsylvania.

35. Plan of Burlington Village, Special Collections, University of Vermont Library, http://cdi.uvm.edu/collections/item/Burlington_Young_1830 (accessed April 12, 2014).

36. *Burlington Free Press*, January 27, 1832, 4.

37. Ibid., 1833, 4.

38. Ibid., September 12, 1834, 4.

39. Ibid., 1833, 4.

40. Map of Burlington, Vermont, 1853, Special Collections, University of Vermont Library, http://cdi.uvm.edu/collections/item/Burlington_Presdee_1853 (accessed April 12, 2014).

41. Abby Hemenway, *Vermont Historical Gazetteer*, vol. 1 (Brandon, VT: Mrs. Carrie E.H. Page, 1867), 706.

42. *Burlington Free Press*. December 30, 1836, 2.

43. Ibid., November 10, 1837, 3.

Chapter 2

44. Ibid., September 11, 1840, 4.

45. Child, *Gazatteer*, 113.

46. Edwin F. Palmer, *Reports of Cases Argued and Determined in the Supreme Court of the State of Vermont*, vol. 54, New Series, vol. 2 (Montpelier, VT: Watchman and Journal Press, 1882), 155.

47. Honorable Hiram Carelton, *Genealogical and Family History of the State of Vermont* (New York: Lewis Publishing Co., 1903), 216–17.

48. *St. Albans Daily Messenger*, June 16, 1874, 4.

49. Justice Timothy P. Redfield, writing for the Vermont Supreme Court in *State v. Smith*, 55 Vt. 82 (1883).

50. *In re Powers*, 25 Vt. 261, 263 (1853). Section 27 of the 1852 act put the effective date of the act to a popular vote, and Vermonters could choose the first Tuesday in March 1853 or first Monday of December 1853. 1852, No. 24, § 27. Vermonters chose March. *State v. Parker*, 26 Vt. 357 (1854).

51. *Powers*, 25 Vt. at 263.

52. Ibid.

53. Ibid., 263–64.
54. Ibid.; 1852, No. 24, § 22.
55. 1852, No. 24, § 22.
56. *Powers*, 25 Vt. at 261.
57. Ibid. Article 10 provided that in criminal prosecutions, a person had the right to be heard "by himself and his counsel," to demand to know the cause and nature of the accusation, to confront witnesses, to present evidence in his favor and to a speedy public trial by an impartial jury. It also provided that a person could not "be compelled to give evidence against himself." Lastly, no person could "be justly deprived of his liberty, except by the laws of the land, and the judgment of his peers"; Vt. Const. ch. I, art. 10. Article 10 was amended in 1977 to use more modern language and to allow a defendant to choose to be tried by a judge alone instead of a jury.
58. *State v. Martin*, 2008 VT 53, ¶ 9, 184 Vt. 23, 955 A.2d., 1144. Although Article 11 has a similar purpose as the Fourth Amendment to the U.S. Constitution, it differs historically and textually, and the Vermont Supreme Court has held that Article 11 provides freestanding protection against unreasonable searches and seizures that "in many circumstances exceeds the protection available" from the Fourth Amendment. The scope of Article 11's protection and how it differs from the Fourth Amendment is a frequently litigated topic, and it could be the subject of its own book.
59. 25 Vt. 265.
60. Ibid., 266.
61. Ibid., 265–66.
62. Ibid., 266.
63. Ibid.
64. Ibid., 266–67.
65. Ibid., 269.
66. Ibid., 272.
67. Ibid., 273. This *Powers* decision rests entirely on an examination of Vermont constitutional law, and Redfield expressly stated he considered the U.S. Constitution only for the persuasive, not controlling, effect it might have for dealing with similar subjects. In 1853, when *Powers* was decided, the U.S. Supreme Court had held that the first ten amendments to the U.S. Constitution, the Bill of Rights, was not applicable to the States, as Redfield well knew. See *Barron v. Mayor and City of Baltimore*, 32 U.S. (7 Pct.) 243, 247 (1833) and 25 Vt. at 273 (both explaining that the U.S. Constitution guarantees rights to be vindicated in the federal courts

and that state constitutions governed rights in state courts). The Bill of Rights would not begin to be applied to local and state governments until the passage of the Fourteenth Amendment to the U.S. Constitution after the Civil War. See generally Erwin Cherminsky, *Constitutional Law* (Aspen, 2001) at 380+ (constitutional law casebook explaining legal history of application of the Bill of Rights to the States).

68. Ibid. 273; *Powers*, 25 Vt. at 273.
69. Ibid. 272.
70. Ibid. 272.
71. Ibid. 272–73.
72. *Powers*, 25 Vt. 270.

Chapter 3

73. *St. Albans Daily Messenger*, December 1, 1871, 4.
74. 1854 House bill, Bellows Falls Brewing Company.
75. Vermont Supreme Court case, volume 29.
76. *Argus Patriot*, "Fall Mountain History," October 24, 1877.
77. U.S. Department of Agriculture, "Seventh Census of the United States Original Returns of the Assistant Marshals: Fourth Series; Manufacturing Production by Counties, 1850," Microfilm 626, Reel 2, Bailey/Howe Microforms, Burlington, University of Vermont. Accessed September 14, 2010.
78. *Burlington Weekly Free Press*, November 15, 1906, 13.
79. *Spooner's Vermont Journal*, February 21, 1820, 4.
80. *National Standard*, February 1, 1820, 4.
81. *St. Albans Messenger*, December 25, 1856, 4. St.
82. *Industries and Wealth of the Principal Points in Vermont* (New York: American Publishing and Engraving Co., 1891), 144.
83. *Vermont Watchman & State Journal*, October 15, 1879, 2.
84. "Panther breath" was a nineteenth-century term that is still used, though rarely, to describe unaged corn or white whiskey.
85. *Vermont Watchman*, February 10, 1892, 1.
86. *Vermont Phoenix*, December 13, 1895, 3.
87. *Burlington Weekly Free Press*, November 21, 1901, 8.

Chapter 4

88. John B. Gough, *The Autobiography of John B. Gough* (London: William Tweedie, 1855), 95.

89. *The Panoplist; or, The Christian's Armory*, vol. 3 (Boston: Lincoln & Edmands, 1808), 266.

90. *Green Mountain Patriot*, April 29, 1806, 4.

91. Frederic P. Wells, *History of Barnet, Vermont: From the outbreak of the French and Indian War to Present Time; With Genealogical Records of Many Families* (Burlington, VT: Free Press Print. Co., 1923), 192.

92. Thomas A. Merrill, *Semicentennial Sermon, Containing a History of Middlebury, VT* (Middlebury, VT: E. Maxham, 1841), 66.

93. Bogart, *Peacham*.

94. Abby Hemenway, *Vermont Historical Gazetteer*, vol. 5, *The Towns of Windham County* (Brandon, VT: Mrs. Carrie E.H. Page, 1891), 526.

95. Duncan Chambers Milner, *Lincoln and Liqour* (New York: Neale Publishing Company, 1920), 18.

Chapter 5

96. Retrieved from https://www.sec.state.vt.us/media/59772/1847.pdf (accessed on March 14, 2014).

97. Retrieved from vermont-archives.org/govhistory/Referendum/pdf/1853.pdf (accessed on February 11, 2014).

98. Ibid.

99. *Rutland Daily Globe*, May 29, 1876, image 2.

100. Retrieved from https://www.sec.state.vt.us/media/59757/1903.pdf (accessed on April 4, 2014).

Chapter 6

101. U.S. Department of Agriculture, "Sixth Census of the United States original returns of the Assistant Marshals: Fourth Series; Agricultural Production by Counties, 1840," Microfilm 625, Reel 2, Bailey/Howe Microforms, Burlington, University of Vermont. Accessed October 2, 2009.

102. U.S. Department of Agriculture, "Seventh Census of the United States Original Returns of the Assistant Marshals."

103. U.S. Department of Agriculture, "Eighth Census, Agriculture, Vermont, 1860," Microfilm 627, Reel 2. Bailey/Howe Microforms, Burlington, University of Vermont. Accessed October 02, 2009.

104. U.S. Department of Agriculture, "Ninth Census, Agriculture, Vermont, 1870," Microfilm 628, Reel 2. Bailey/Howe Microforms, Burlington, University of Vermont. Accessed October 03, 2009.

105. Walter H. Crockett, *Vermont: Its Resources and Opportunities* (Montpelier: General Assembly of the State of Vermont, 1916), 36–37.

106. *Reporter*, May 24, 1806, 4.

107. *Rutland Herald* , March 2, 1805, 2.

108. *Brattleboro Messenger*, June 20, 1828, 4.

109. *Vermont Centinel*, June 14, 1804, 4.

110. *Green Mountain Patriot*, August 8, 1799, 4.

INDEX

ABOUT THE AUTHORS

Adam Krakowski is a decorative and fine arts conservator based in Quechee, Vermont. He holds a BA in art history with a minor in museum studies and a MS in historic preservation from the University of Vermont. He has worked at museums, historical societies, art galleries and restoration firms all over New York and New England. He was the recipient of the 2010 Weston Cate Jr. Research Fellowship from the Vermont Historical Society for his project *A Bitter Past: Hop Farming in Nineteenth-Century Vermont*.

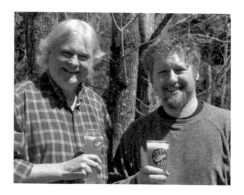

Kurt and Adam. *Photo by Patti Staudter.*

Kurt Staudter is the executive director of the Vermont Brewers Association, which represents all the breweries in the state. He is also the Vermont columnist for the *Yankee Brew News* and has written about beer and politics in the *Vermont Standard* and *Vermont Magazine*. He learned about beer at a very early age (perhaps a little too early by today's standards) from his first-generation German American father, who made sure that his love for good food, great beer and family were passed on to the next generation. Along with his wife, Patti, he runs the trade association for the Vermont brewers from Springfield, Vermont.